POSTCARD HISTORY SERIES

Around
Boynton Beach

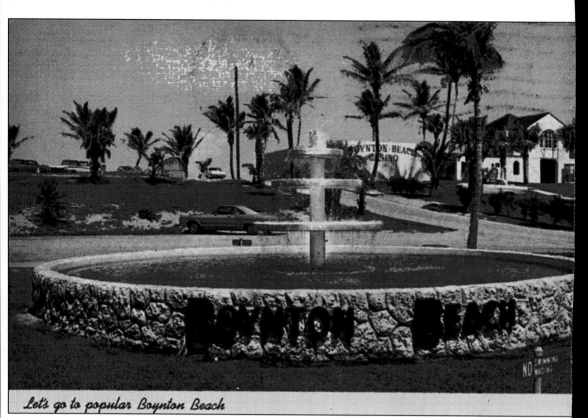

Let's go to popular Boynton Beach

BOYNTON BEACH CASINO. The municipal beachfront park facility known as "The Casino" was built in the 1920s and used for dances, parties, bathing, and barbecues. The facility was torn down in 1967.

ON THE FRONT COVER: A guest looks out on the beach from the front porch of the oceanfront Boynton Beach Hotel in this *c.* 1900 postcard. The two-story hotel was the winter home of Michigan businessman Maj. Nathan Smith Boynton. He built the hotel as an escape from the cold, Northern winters for his affluent friends. (Courtesy Sheila Rousseau Taylor.)

ON THE BACK COVER: This postcard made from an actual photograph shows downtown Boynton Beach as it was in the 1940s. The view is of Ocean Avenue looking east from the Florida East Coast Railroad. For nearly three-quarters of a century, this street was the hub of business and shopping activity in Boynton Beach. Sadly the historic buildings shown on the south side of Ocean Avenue were demolished in 2006 to make way for a new development.

POSTCARD HISTORY SERIES

Around Boynton Beach

Janet DeVries

ARCADIA
PUBLISHING

Published by Arcadia Publishing
Charleston, South Carolina

Printed in the United States of America

Library of Congress Catalog Card Number: 2006926972

For all general information contact Arcadia Publishing at:
Telephone 843-853-2070
Fax 843-853-0044
E-mail sales@arcadiapublishing.com
For customer service and orders:
Toll-Free 1-888-313-2665

Visit us on the Internet at www.arcadiapublishing.com

To my mother, Rita G. Gardner, this book is lovingly dedicated.

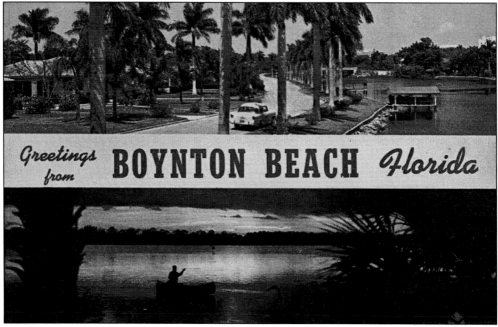

GREETINGS FROM BOYNTON BEACH. This picture postcard of Boynton Beach shows waterfront homes nestled between North Federal Highway and the Intracoastal Waterway and reflects the natural beauty of the area. In the 1950s, when this image was taken, the area west of the city of Boynton Beach was predominantly dairy or vegetable farms.

CONTENTS

Acknowledgments 6

Introduction 7

1. Two Men Who Shaped the Area 9

2. Working, Living, and Farming 21

3. Stay and Visit Awhile 35

4. A Life of Leisure 51

5. The Natural Habitat 69

6. The Town Grows 77

7. Living in Paradise 97

8. Land of Sunshine 105

9. Catch of the Day 115

Bibliography 127

ACKNOWLEDGMENTS

Assembling this book of vintage postcards chronicling pioneers, communities, events, and landmarks that shaped our Gold Coast heritage has been an exhilarating and enlightening learning experience. The more information I collect, the more I realize how much I have to discover about our colorful and rich history.

I give loving appreciation to my family for supporting me and sacrificing so much time apart as I spent endless weeks and hours researching and writing this book. For months, I had my head in a book or my eyes glued to the Internet, and a growing sheaf of papers took over the house. Gratitude is expressed to editor Adam Ferrell for his patience and advice in preparing this book.

The Boynton Beach City Library staff as well as the Schoolhouse Children's Museum founder Arleen Dennison and her staff were insightful when they encouraged me to take on the task of telling the story of *Around Boynton Beach* in picture postcards. My colleague and fellow Arcadia author Susan Gillis answered many questions and gave myriad advice. I give recognition to M. Randall Gill, who first contracted with Arcadia on Images of America: *Boynton Beach* and asked me to coauthor. Randall paved the way for future publications chronicling our area's illustrious past.

This book would not be possible without the following individuals who provided contributions and support: Ingrid Anderson, Brian Banks, Madeleine Ehrhardt, Judi Marsh Garrity, Janet Hall Garnsey, Lee Heit, Cindy Lyman Jamison, Sam Marks, Dorothy Mann McNeice, Joanne Miner Shoemaker, Harvey Oyer Jr., Dorothy Patterson of the Delray Beach Historical Society, Bobbi Pruitt, Lenore Benson Raborn, Judith Sanders, Pat Servant, Susan Sinclair, Voncile Smith, Debra Tau Sowers, Sheila Rousseau Taylor, Howard Waite, Curtis Weaver, Stanley Weaver, and Marge Whetzell.

The majority of postcards were culled from my personal postcard collection. The book would not be as rich without the images loaned from the collections of locals and former area residents. Deep appreciation and recognition is given to the Boynton Beach City Library, Boynton Beach Historical Society, Henry Huggins, Cindy Lyman Jamison, the Mann family, the family of James T. and Bernice Miner, and Sheila Rousseau Taylor.

A final word of appreciation goes to those early settlers of our town who paved the way so that we may live in comfort, beauty, and sunshine and to those who have had the foresight and perseverance to save and record its history for future generations.

INTRODUCTION

This book is not intended to be a comprehensive history of the Boynton Beach area, but rather a factual and entertaining journey into the remote and humble beginnings of the area I have come to know and love.

Every town has a story to tell. Picture postcards, many mailed across the country to friends and family, some lovingly collected in scrapbooks, have been gathered and assembled here to entertain and delight the reader and to chronicle the history of one of the most beautiful tropical locales in the United States. Our story begins with empire builder Henry Flagler, who opened up the new frontier with his railway to paradise, and Maj. Nathan Boynton, the town's namesake who is featured within the pages of this book along with a charming view of his beachfront resort, the Boynton Beach Hotel.

In the late 1890s, acreage could be purchased for practically nothing, and people eager to escape the rigors of long, cold winters took a chance in this newly accessible territory, seeking new opportunities and new horizons. Experiencing many hardships and privations, they maintained courage, vision, and faith in the future. The wilderness around them was filled with insects, snakes, and animals such as black bear, panthers, skunks, and opossums. Despite the elements, the pioneers worked hard and found beauty and tranquility amid the scrub palmetto, slash pine, and palm trees. Abundant wild game as well as sea grapes, prickly pear, wild sweet potatoes, and wild orange trees provided a tropical fare. The clear blue skies, calm water, and ocean breezes with the abundant sunshine warmed their spirits.

In just a few years, the town grew with houses and shacks springing up along white, shell-rock roads. New schools, churches, community halls, and municipal services were established in a growing downtown. Inspired by the rich soil and favorable winter climate, the first residents tilled the land and grew crops year-round. During this time, postcards were an important form of contact to family and loved ones in other cities and were a essential form of communication in the days before the telephone. In 1900, there were about 100 people living in Boynton.

In the 1920s, the great Florida land boom brought land speculators and investors. It seemed everyone wanted a slice of the good life. Many invested in acreage or oceanfront property. Sales were moving so quickly in the world of real estate, binder-boys bought property in the morning with five percent down and in the afternoon peddled it for a higher price. Then came the bust, followed by the devastating hurricanes of 1926 and 1928. The Great Depression had arrived, and banks closed; the bottom fell out, and many discouraged residents left town for good.

In the 1930s, the east coast of Florida recovered quickly, and establishments for eating and drinking and tourist attractions of all sorts sprang up along U.S. 1, or Dixie Highway, as it was known. The residents worked hard but enjoyed a multitude of simple pleasures including ice cream socials, hayrides, baseball games, picnics, bonfires on the beach, and dances.

Many townsfolk volunteered their services during World War II, flying for the Civil Air Patrol, tracking German submarines off the coast. A few brave swimmers collected debris from downed ships floating in the ocean. During World War I, postcards were great morale builders. The picture and the writing told the story the home folks wanted to see and hear.

After the war ended, tropical Florida was touted as the perfect paradise, and every farm, cattle ranch, and citrus grove was soon covered with houses. Tourist courts, hotels, motels, and motor inns soon lined both sides of the highway. Photo postcards, originally just a quick and inexpensive form of communication, became key elements in South Florida's growth. The images on the cards and the messages on the back became witness to the major events, businesses, and landmarks of modern times.

I hope you enjoy the visual journey though each rich segment of Gold Coast history. Looking at the old photographs of A1A may conjure up visions of your own of beach volleyball games, convertibles cruising along the beach, mahi mahi sizzling on the grill, or margaritas spinning in the blender. While some of the area has changed, the very reasons people came here in 1894 are the same reasons the Boynton area is such a nice place to live and grow up in today. Each of the early entrepreneurs, leaders, and citizens from our past has left an indelible mark upon the land.

One of the best collections documenting passing times are those of photographs, postcards, and stamps. Each image brings back thousands of memories for the collector, and as time goes by, the messages and pictures become a historical record.

Around Boynton Beach is a tribute to the founders of the Boynton area, to its influential residents, both rich and poor, and to anyone who has visited and enjoyed the area's natural beauty. May this book be your key to unlocking for yourself the rich treasure of our history.

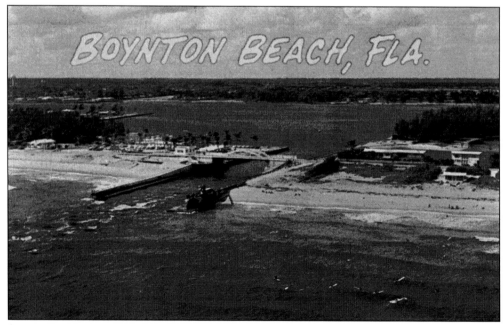

SOUVENIR POSTCARD. Postcards like this town view of Boynton Beach were sold at grocery stores, drugstores, and souvenir shops. Visitors bought handfuls of postcards to document their trip or to mail to friends and family. Plain postcards were first printed in 1840 and were sent in envelopes because what you wrote was considered private. Up until 1880, all were printed in black and white. By 1910, three-color printing was adopted, and demand for colorful postcards grew.

One

TWO MEN WHO SHAPED THE AREA

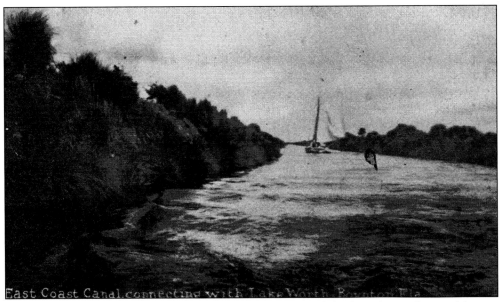

EAST COAST CANAL. Early pioneer Frederick Voss's naphtha launch, similar to this one, ferried Michigan statesmen Nathan Boynton and William Linton down the East Coast Canal on their safari to Florida in 1894. Major Boynton liked what he saw and bought 500 acres of land. Congressman Linton bought land to the south, and his settlement was known as Linton. In 1898, the name of Linton was changed to Delray, after Delray, Michigan.

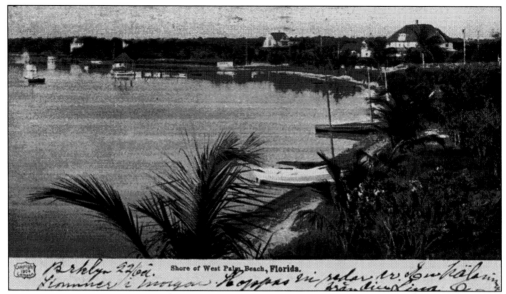

Shore of West Palm Beach, Florida.

THE "AMERICAN RIVIERA." Visiting Palm Beach in 1884, Henry Flagler felt the atmosphere rivaled the best vacation spots in the world. He was determined to build luxurious hotels to create an "American Riviera." First was the six-story Hotel Royal Poinciana, named after the flaming Royal Poinciana trees. He then built the Palm Beach Inn, later called the Breakers. The beachfront hotel burned in 1903. A second, more luxurious Breakers was built in 1904, and it burned in 1925. The third Breakers, built in 1926, cost over $6 million.

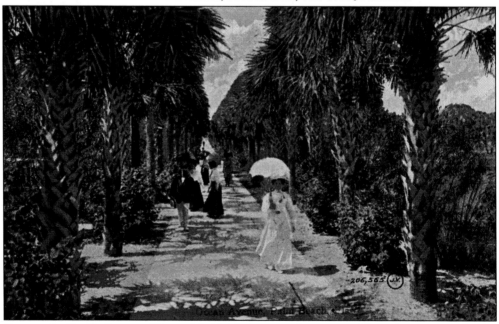

FLAGLER'S PALM BEACH. Henry M. Flagler possessed great wealth and a concern for his fellow man. He worked for the betterment of the people of southeast Florida. The freezes of 1896 prompted Flagler to look toward development farther south, beyond the reach of freezing temperatures. Flagler's system issued free vegetable seed to areas struck by the freeze. Fertilizer was hauled without cost to farmers as well as crates for shipping.

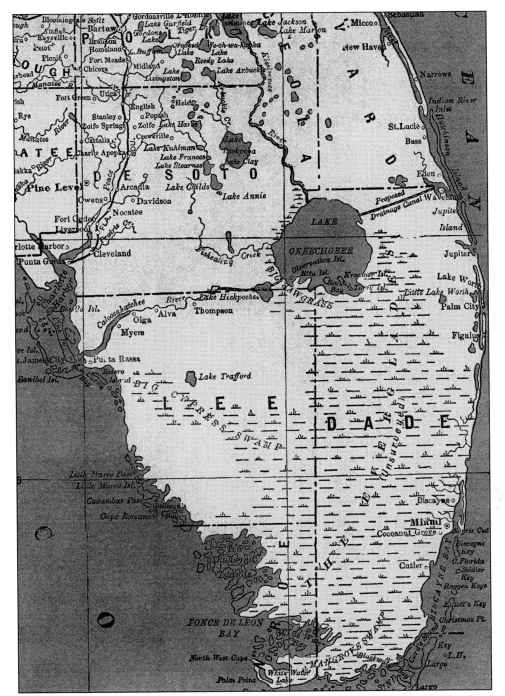

MAP, 1880. This *c.* 1880 map illustrates how desolate and undeveloped South Florida was before Henry Flagler extended the railroad south. The east coast shows a vast swampy area simply known as the Everglades with the names of a few tiny settlements such as (Fort) Jupiter, Lake Worth (the body of water), Figulus (Palm Beach), and Miami dotting the coast. These vicinities were remote outposts, cut off from the rest of the world, except by ship. Palm Beach County did not exist until 1909; it was part of Dade County.

ON LAKE WORTH. Prior to 1879, Lake Worth was a freshwater lake. Early settlers cut a ditch through it at the north end of the lake, enabling the ocean waters to ebb and flow until there was an inlet. In 1894, a canal was dredged from the lake's south end to connect natural lagoons; along with the railroad, this opened the southeast Florida coast for settlement and farming for the first time.

828 A TREE LOADED WITH COCOANUTS IN FLORIDA

COCONUTS! In 1878, a small Spanish brigantine, *The Providencia*, wrecked off the coast of Palm Beach with a cargo of 20,000 coconuts. These coconuts were planted by the settlers and became the main source of the coconut palm trees. Some of the colonists reportedly sold the coconuts for $2.50 per hundred, and coconuts were planted across the land, giving Palm Beach its name.

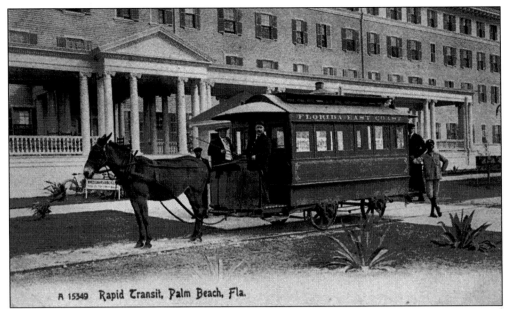

A 15349 Rapid Transit, Palm Beach, Fla.

RAPID TRANSIT. Following completion of the Royal Poinciana and Breakers Hotels, the Florida East Coast (FEC) Railway constructed a mule car line painted with the company name. It traveled on a track more narrow than a railroad, taking guests from the railway station to the hotels. After passengers disembarked, the driver unhitched the mule, walked it around to the other end, and hitched the mule back. The route was Australian Avenue, and the fare was 5¢ a day.

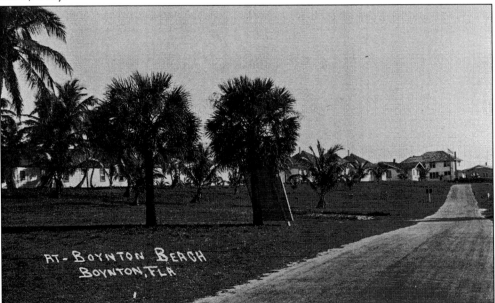

AT-BOYNTON BEACH
BOYNTON, FLA

THE TROPICS. This palm-lined walkway led to the Oceanside Boynton Hotel. Since 1872, the FEC and its steel rails have been the reason that people came to Florida's east coast. After Flagler's first passenger train arrived, the area exploded with growth. People wanted to holiday as far south as transportation would take them. Folks came for the sunshine; the lush vegetation and palms cast a spell over them. (Courtesy Sheila Rousseau Taylor.)

13

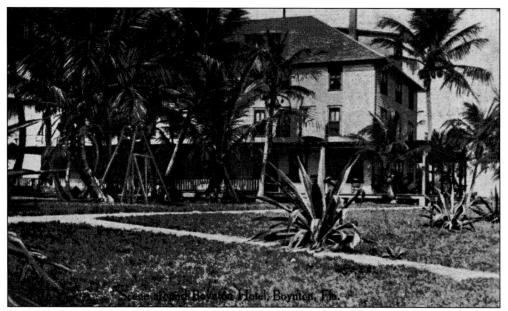

BOYNTON'S FIRST HOTEL. The exclusive Boynton Beach Hotel was conceived and built by Maj. Nathan Boynton in 1896, closely following the construction of Henry Morrison Flagler's Florida East Coast Railroad. The complex included a main building with a fine dining room and five cottages. A. A. Atwater managed the 45-room tourist hotel. Many of the original guests were from Michigan.

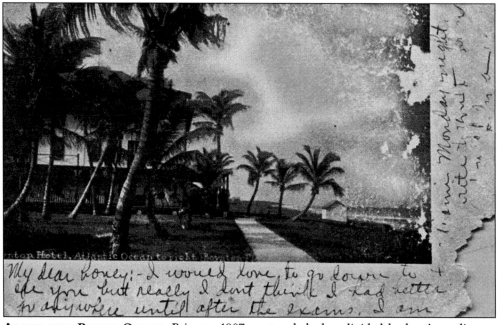

ALONG THE BALMY OCEAN. Prior to 1907, postcards had undivided backs. According to postal regulations, only the address could go on the back. This Boynton Beach Hotel scene on the Atlantic Ocean has correspondence on the card's front. The message to Louise in Fort Lauderdale reads: "My dear honey: I would love to go down to see you but really I don't think I had better go anywhere until after the exams." The sender's name has worn off.

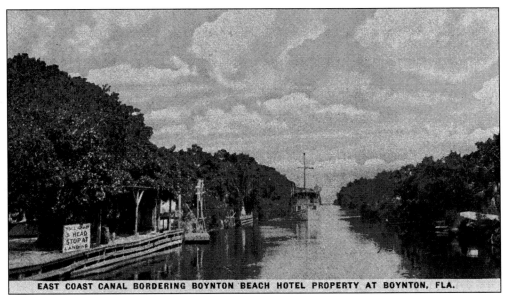

TOLL CANAL. This card shows the canal bordering the Boynton Beach Hotel property. Notice the sign: "Toll Chain Ahead. Stop At Landing." The waterway was originally a private toll canal run by the Florida Coast Line Canal Company. This image is *c.* 1900, when Boynton had a mere 83 residents. Population growth choked Lake Worth with pollution, leading to the 1925 creation of the Boynton Inlet, also called the South Lake Worth Inlet. (Courtesy Sheila Rousseau Taylor.)

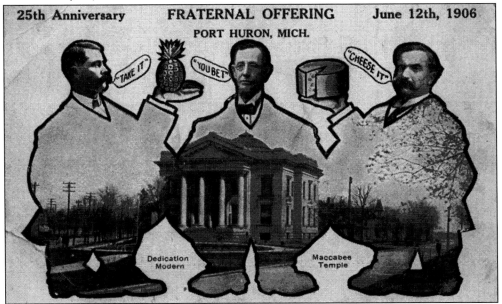

FRATERNAL OFFERING. This rare political postcard from Port Huron, Michigan, of "Father" Boynton commemorates the 25th anniversary of the Knights of the Maccabees. Dated 1906, the card depicts, from left to right, Napoleon Bonaparte Broward (governor of Florida), Nathan S. Boynton, and Fred M. Warner (governor of Michigan). Governor Broward holds out a pineapple as an offering, while Governor Warner extends a round of cheese in his hand. The Maccabee Temple is in the center.

SCENE AROUND BOYNTON HOTEL. A guest staying in one of the cottages at the seaside Boynton Beach Hotel mailed this postcard bearing the following message to her friend in Detroit, Michigan, on February 19, 1913: "Won't you return & bathe with me? First at 6:30 on rising & again at noon. We do enjoy it here, as you did. Today a real ocean gale is roaring . . . arrived here Sunday-for a few weeks stay."

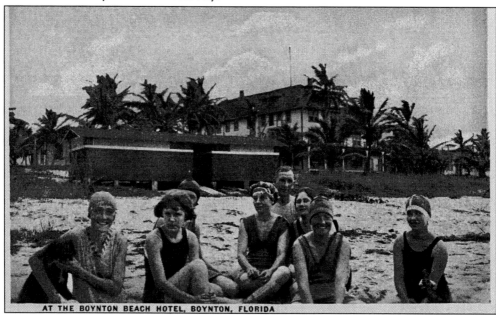

AT THE BOYNTON BEACH HOTEL, BOYNTON, FLORIDA

THE BATHHOUSE. Notice the dressing rooms between the Boynton Hotel and the youngsters relaxing on the seashore. A person showered by pulling a string to open the valve connected to the water barrel overhead. The beach was quite wide in the 1920s. After the first full moon in the summer, adventurers watched for turtles to lay their eggs. The tiny eggs were boiled and eaten with butter, pepper, and salt or made into pancakes. (Courtesy Sheila Rousseau Taylor.)

16

ROAD FROM THE BOYNTON BEACH HOTEL TO VILLAGE OF BOYNTON, FLORIDA.

BOYNTON'S FIRST ROAD. This image portrays Ocean Avenue from the Boynton Hotel to the village of Boynton, *c.* 1910. The reverse reads: "Mr. and Mrs. E. F. Bailey announce their leaving for their winter home at Boynton Beach, Florida, on or about December 1st. Mail for them should be addressed (up to April 1st) to Boynton, Palm Beach County Florida, and after that to 1001 Washington St., Michigan City, Indiana, but mail coming to either address after they have left will be forwarded to wherever they are."

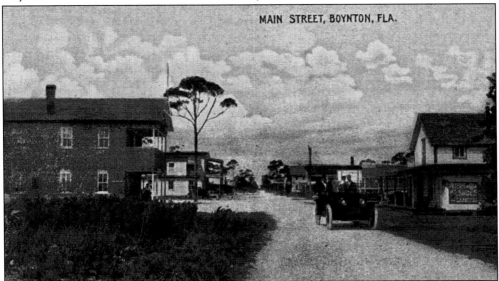

MAIN STREET, BOYNTON, FLA.

MAIN STREET 1910. Boynton was a small farming town with no paved roads and about 800 residents. It had three churches, a bank, pharmacy, barbershop, post office, several dairies and grocery stores, hotels, and two schools. Palm thickets covered the undeveloped land to the west. Settlers prepared simple meals from natural foods, including sweet potatoes, pickled mangoes, and green peppers. Roasted meat from razorback hogs, deer, and wild turkey provided protein.

17

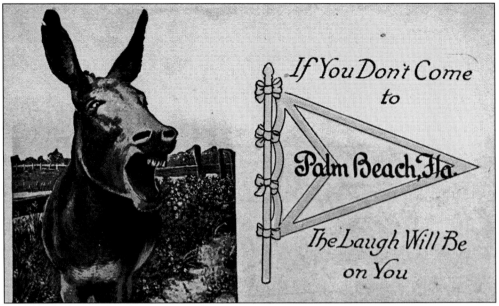

PALM BEACH PENNANT CARD. This unusual pennant postcard with the donkey graphic and message warns, "If You Don't Come to Palm Beach, Fla. The Laugh Will Be On You," and was used as a promotion for Palm Beach. The pennant postcard was a stock card carried by a publisher, which could be imprinted with a town/city name on request.

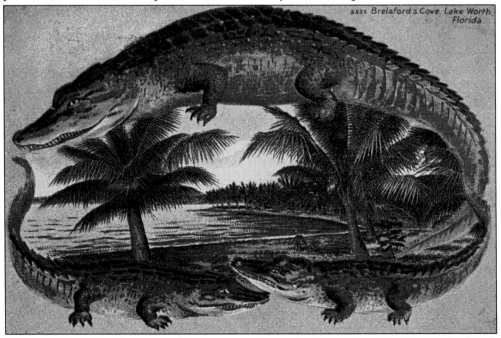

BRELSFORD COVE. This postcard with unique alligator border is of Brelsford Cove, a landmark on peaceful Lake Worth. In 1974, this site at Number One South Lake Trail in Palm Beach was added to the National Register of Historic Places. In the backyard along the bike trail is a magnificent ceiba tree that pioneer Dr. John H. Brelsford planted from seed; his initials are still in the tree. (Courtesy Sheila Rousseau Taylor.)

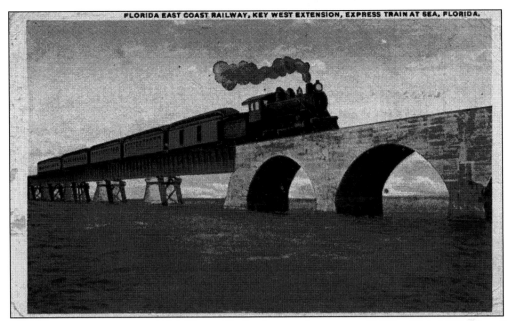

OVERSEAS RAILROAD. In 1904, Henry Flagler began what some call "The Eighth Wonder of The World," the Overseas Railroad. Many Boynton men, including Thornton Bridgman and Charles Pierce, worked on the railroad south to Key West. Hurricanes, malaria, snakes, and washouts delayed the construction. On January 2, 1912, the *Extension Special* carried Henry Flagler over the tracks. The old man wept, expressing gratitude to his employees. Four months later, he passed away.

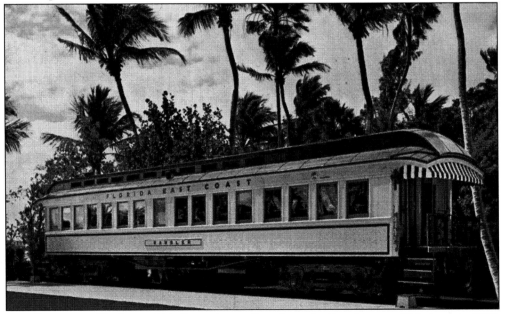

THE RAMBLER. Flagler used his first private railroad car, the Rambler, until his death in 1913. The car was in the vanguard of the first train to Key West in 1912. The car, which had been badly deteriorated, was restored in 1966 and brought back to its former splendor. The Rambler is on display at Henry Flagler's Palm Beach home, Whitehall, now the Flagler Museum.

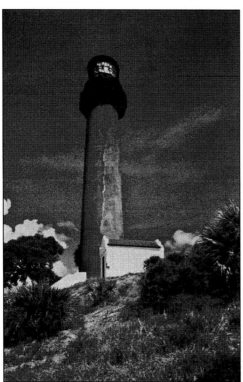

JUPITER LIGHTHOUSE. This early-1930s view shows the landmark Jupiter Lighthouse. The 125-foot lighthouse was built on a coastal bluff in 1860 and served to guide ships along our shores and warn seafarers of the dangerous rocks and sandbars. The lighthouse remains in use today, its light visible from 25 miles at sea.

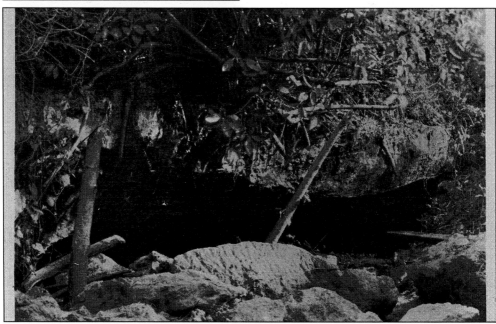

GULF STREAM CAVES. Children loved to play in these coral rock cave formations extending from the edge of the ocean through the ocean ridge. The larger cave was about 20 by 20 feet and high enough for a man to stand upright. The second cavern was pitch black and accessible by crawling only; one had to keep on the lookout for snakes. More mansions were built along the ridge, and the caves were dynamited shut in the 1970s.

Two

LIVING, WORKING, AND FARMING

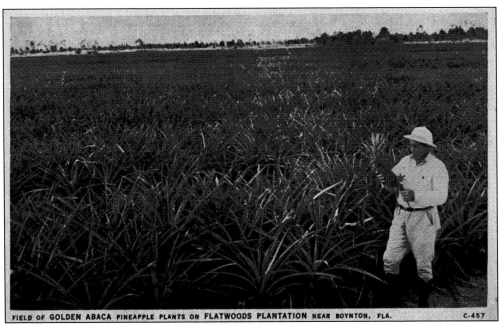

FIELD OF GOLDEN ABACA PINEAPPLE PLANTS ON FLATWOODS PLANTATION NEAR BOYNTON, FLA. C-457

GOLDEN ABACA PINEAPPLES. In 1932, Oscar R. Winchester (shown here) and Fred G. Benson made their first planting of golden abaca pineapples. Their 550 acres of sweet, juicy pineapple usually ripened in late July after the Cuban crop of Red Spanish was finished. Thus the market was not as glutted as it was earlier in the season and a better yield was received. In the 1930s, about 96 percent of the acreage of golden abaca pineapples grown were in Palm Beach County.

21

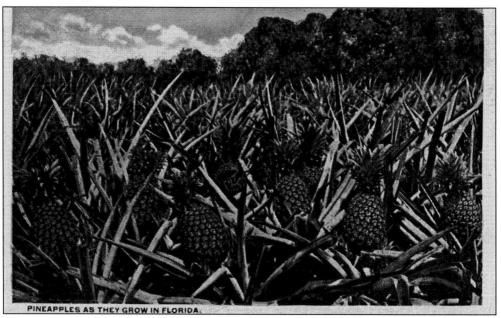

PINEAPPLES AS THEY GROW IN FLORIDA.

PINEAPPLE PLANTATIONS. Pineapples were an important crop and shipped north in great quantity. Oscar Winchester, a local farmer, wore long sleeves to protect his arms from the sharp spines. Only the finest were shipped for markets. Winchester would sometimes cut off the sides of the overripe pineapples and offer the remaining stem and sweet fruit "pineapple pop" to the children of the packinghouse workers.

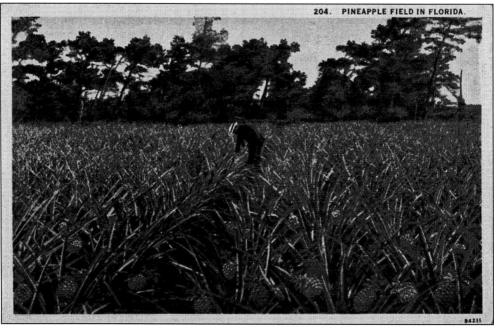

204. PINEAPPLE FIELD IN FLORIDA.

PINEAPPLE FIELD. Patches of pineapples grown in high ridges of sand were a common sight. Pineapple slips were trimmed and planted in the ground. As a youth, pioneer Charles W. Pierce set 6,000 pineapple plants in six days. He earned $6 and used the money to buy a violin. The pineapple is an old symbol of hospitality and can often be seen in carved decorations.

22

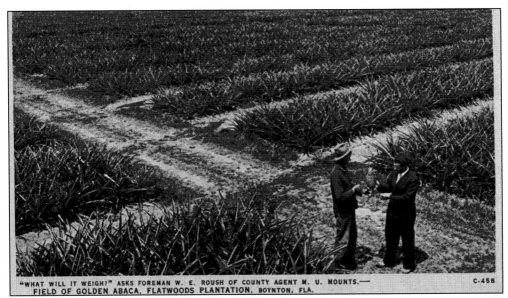

"WHAT WILL IT WEIGH?" ASKS FOREMAN W. E. ROUSH OF COUNTY AGENT M. U. MOUNTS.— C-458
FIELD OF GOLDEN ABACA, FLATWOODS PLANTATION, BOYNTON, FLA.

WHAT WILL IT WEIGH? Palm Beach County agriculture agent Marvin U. Mounts (right) examines a hearty pineapple extended by foreman W. E. Roush on the Winchester farm. Marvin "Red" Mounts was agricultural agent from 1925 until the 1960s, during which time the county's agriculture value grew from $2 million to $120 million, and Palm Beach County led the country in the production of corn and green beans. Mounts formed Florida's first 4-H Club; Mounts Botanical Garden is named after him.

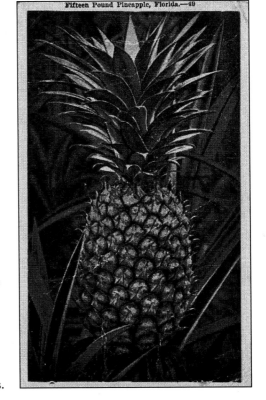

Fifteen Pound Pineapple, Florida.—49

FIFTEEN-POUND PINEAPPLE. The average pineapple today weighs between one and nine pounds. This record-breaking pineapple weighed 15 pounds. Pineapples yield only one apple per plant. A contributing factor to the end of the pineapples was drainage operations by the Everglades and Lake Worth Drainage District. The plants could not get enough water to properly develop and were smaller each year. It takes 48 small pineapples to fill a crate that would normally hold 18 large apples.

23

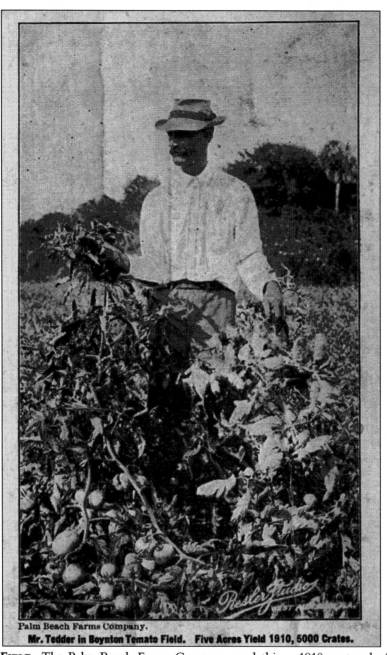

Palm Beach Farms Company.
Mr. Tedder in Boynton Tomato Field. Five Acres Yield 1910, 5000 Crates.

TOMATO FIELD. The Palm Beach Farms Company used this *c.* 1910 postcard of Littleton Tedder in a tomato field to entice new farmers and investors to the Boynton and Lake Worth area. Advertisements like these were sent to prospective buyers in Illinois, Michigan, and other Midwestern states, promoting Palm Beach County, Florida, as "the garden spot of the world." Five acres yielded 5,000 crates. In the 1910 census, over half the Boynton area men listed their occupation as "truck farming." Developers Bryant and Greenwood urged prospectors to set aside 34¢ a day and own a beautiful, semi-tropical home for $250: "$10 down and $10 a month buys one of our contracts. We give a town lot free to each purchaser." The free lots were only 18 feet wide.

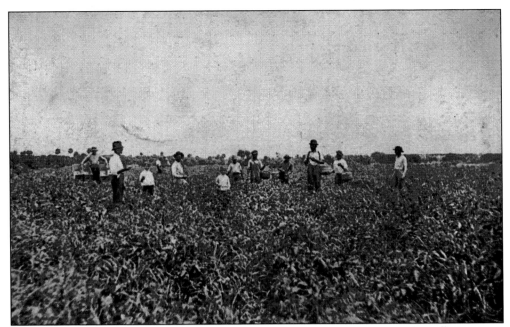

TRUCK FARMING. This *c.* 1915 image shows a tomato farm between Delray and Boynton. The note from Leonard L. Barwick to his mother in Pine Park, Georgia, tells about the picture card: "Dear Mother. The other side shows us gathering tomatoes; the season will soon be over and not very profitable. The weather is getting hot here, but . . . yet, all are well, but lazy. Yes, I was on the other card. I had an overcoat is why you didn't know me. Leonard." Barwick was a farmer and then dealt in real estate during the Florida land boom. Barwick Road and Barwick Park bear his name.

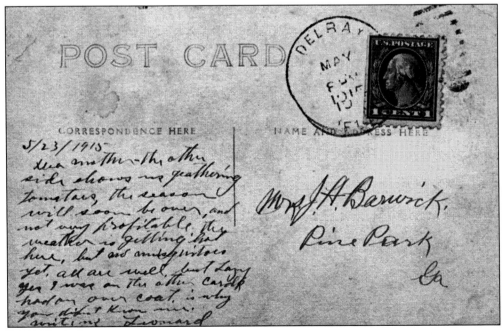

CITRUS SCENE. In the early days, citrus groves, like the one depicted here, and pineapple fields covered the landscape. A home seeker's booklet from 1901 states, "Orange and pineapple business booming—hundreds of acres being cleared and planted in citrus trees and pineapples." The farmers ate and traded what they could and packed up the rest of the crop, taking it to the train station with dreams of a profitable cash crop.

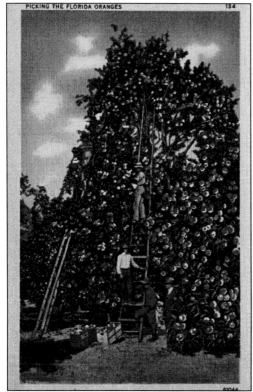

PICKING THE FLORIDA ORANGES 134

CRATING ORANGES. Harvesters use their fruit knives to peel the orange halfway down from the blossom end. They ate the sweeter and juicier blossom half and threw away the stem end. Green oranges still on the tree can be sweet and ripe inside. Cool weather changes the emerald color into flaming orange. The first settlers cultivated pineapples, tomatoes, mangos, oranges, lemons, grapefruits, and limes. These were crated and shipped by the ton on the newly built Florida East Coast Railroad.

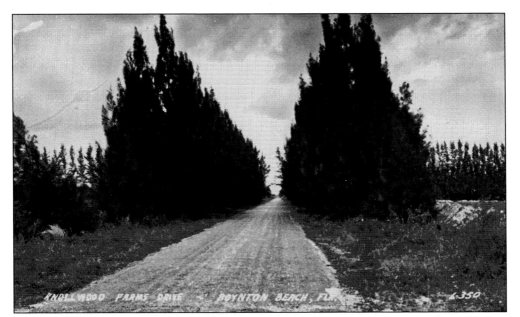

KNOLLWOOD FARMS DRIVE. This shell road ran from Boynton to Lantana. Knollwood Farms Drive was named Lawrence Road in the 1950s by Hy Lawrence and his brother, Red, a land owner who allowed Boy Scouts and other groups to hold retreats and camp on his ranch. The road led to Knollworth Groves, later widely known as Knollwood Groves, a citrus fruit shipper and tourist attraction. Notice the rows of Australian Pines planted as a windbreak to protect the groves.

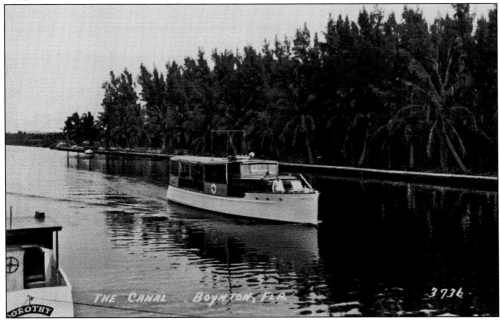

THE CANAL. This peaceful shot of a boat cruising the Florida East Canal shows the natural beauty of Boynton before there were mansions lining the waterways. In the 1920s and 1930s, it was not unusual to use a boat or launch to travel to visit friends in nearby towns or to go shopping in West Palm Beach or Fort Lauderdale.

27

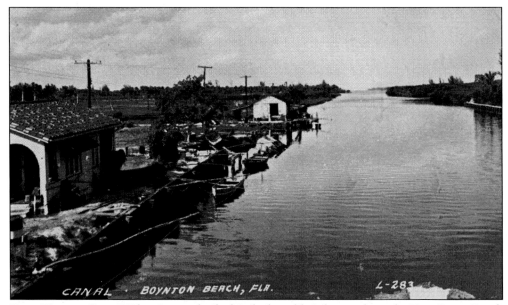

BAIT HOUSE. Capt. Walter Lyman built this dock and bait house along the East Coast Canal. He was a commercial fisherman and constructed boats to rent and kept supplies for those who rented from him. He caught shrimp and mullet for bait. Captain Lyman had two sons who grew up to be capable fishing skippers like their father. In the early 1900s, the ocean and the lake were filled with fish and shellfish. (Courtesy Cindy Lyman Jamison.)

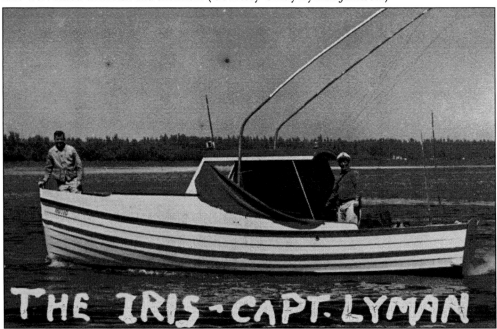

EARLY FISHERMAN. This early view shows Capt. Walter Lyman, the first commercial fisherman in Boynton, at the helm of one of his fishing vessels on the Intracoastal Waterway. Captain Lyman (or "Pop" as he was called) taught sons Kenny and Harold the fishing business. His parents were among the first settlers in the Lantana and Boynton Beach areas, arriving in the 1800s. (Courtesy Cindy Lyman Jamison.)

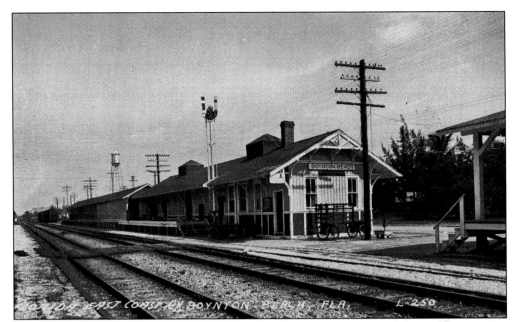

RAILROAD CROSSING. Flagler's railroad was the lifeblood of transportation and the beginning of progress on the east coast of Florida. Farmers began exporting their harvest of pineapples, tomatoes, peppers, beans, and other fruits and vegetables. This view of the old Florida East Coast Railway shows a row of packing houses beyond the station. Notice the double train tracks. In 1977, the tracks were reduced to a single rail. (Courtesy Boynton Beach Historical Society.)

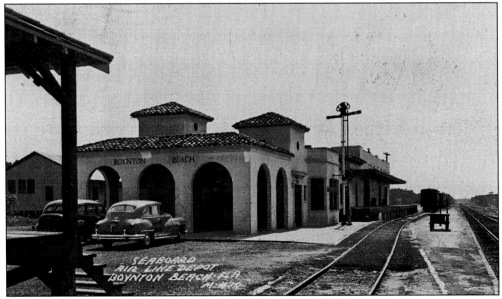

SEABOARD AIR LINE RAILWAY. The Seaboard Air Line Railway station is Mediterranean Revival style, designed by architects Harvey and Clarke. Arched open-air waiting areas, decorative square towers, and entrance moldings distinguish this. The *Orange Blossom Special* first rumbled through in January 1927. Both the FEC and the Seaboard played significant roles in Boynton Beach's commercial and agricultural development. In 1971, the station was used as an East Coast Amtrak Station. (Courtesy Boynton Beach Historical Society.)

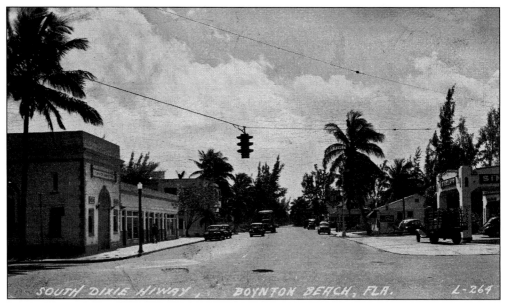

SOUTH DIXIE HIWAY, BOYNTON BEACH, FLA. L-264

SOUTH DIXIE HIGHWAY. This town view shows the intersection of Ocean Avenue and Dixie Highway, looking south. In 1917, the Dixie Highway was paved from end to end in Palm Beach County. The paved roads were built with oyster shells and rock shipped from quarries near Miami, with simple oil and sand surfaces. When Dixie Highway was widened in the 1950s, cars were no longer able to park along the street.

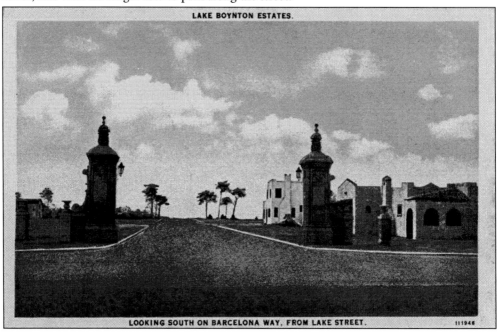

LAKE BOYNTON ESTATES.

LOOKING SOUTH ON BARCELONA WAY, FROM LAKE STREET.

LAKE BOYNTON ESTATES. This real estate postcard from the 1920s advertises Boynton's first planned community. The palm trees and stately columns showcase the idyllic neighborhood of new Mission-style homes developed by K. D. Purdy. The back of the card reads, "Located on the Ridge in the town of Boynton between Lake Boynton and the Atlantic Ocean. This view is reproduced from an actual photo. Visit the semi-tropics."

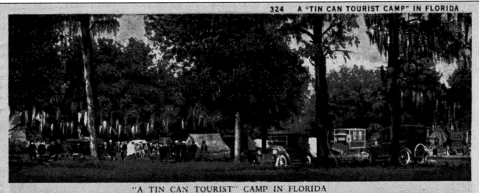

"A TIN CAN TOURIST" CAMP IN FLORIDA

Neath spreading oak and pine tree tall	Then other tourists come along,	And ere the blooming May comes round
"A tin can tourist" in the Fall	The camp force now is growing strong,	They'll buy a piece of fertile ground
Puts up his tent and plans to stay	Cars from the North, the East, the West,	And mark it off in streets and squares
In Florida till blooming May,	Bring weary tourists seeking rest,	And every tourist take some shares,
And soon another tourist comes,	All happy in this flowery glade	For they will build a city here
They meet and greet like old time chums,	Beneath the broad oaks welcome shade.	When they come back another year
They tell new jokes and make new plans,	They're singing songs and making plans	Just as the "tin can tourist" plans
And mess from out the same tin cans.	And piling up the empty cans.	When he piles up the empty cans.

Ruth Raymond

TIN CAN TOURISTS. This *c.* 1930s card pays homage to the "Tin Can Tourist" who heads south each year to camp in the temperate Florida climate. These hardy travelers carried their beds in the back of their trucks and subsisted on canned goods. Despite the cheery poem on the front, the message on the card, postmarked 1934, laments, "Had three days and nights of thunderstorms so far. Had tire trouble, ignition trouble, battery and engine trouble. Have got started again."

SHORE ACRES. Ward B. Miller arrived from Michigan in 1905 and owned this stretch of beachfront property. Calling the area Shore Acres, he operated Shore Acres Dairy. During the 1925 land boom, Miller sold his cattle and hired a development company to plot a community called Briny Breezes. The idea died with the land bust. However, Miller's property eventually became the town of Briny Breezes. This card shows sections one and two before sections three and four were built next to the Intracoastal Waterway. (Courtesy Mann family.)

BRINY BEACH. The Briny Breezes property began attracting visitors in the 1930s. Cars with travel trailers pulled off old A1A to spend the night, and the visitors bought vegetables and strawberries from Ward Miller's roadside stand. After Miller died, his son, Paul, envisioned a fashionable trailer park on the property. In 1958, the nonprofit Briny Breezes Club bought the property from the Miller Trust for $1.5 million. On April 16, 1963, the trailer community was incorporated into a town. (Courtesy Mann family.)

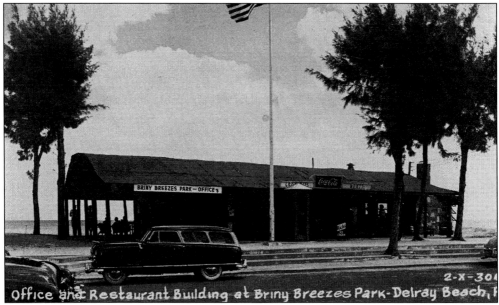

BRINY BREEZES OFFICE. In the 1930s, this building on the ocean housed the offices for the Briny Breezes Park. There also was a snack shop and a post office. The snack shop became the SeaScape Restaurant in the 1950s. Cars are seen driving on old A1A, which was washed out in the 1947 hurricane. A new A1A was constructed a few blocks to the west; the old road is now called Old Ocean Boulevard. (Courtesy Mann family.)

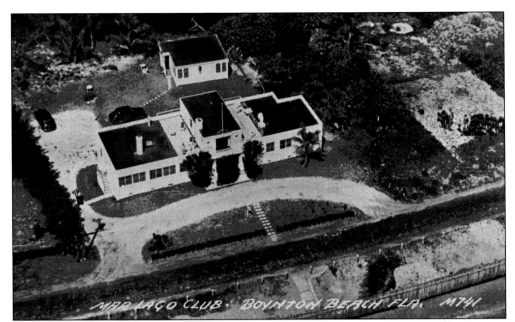

MAR LAGO HOTEL. This aerial view shows the Mar Lago Hotel built in 1932 by Martha and Leon Robbins from Cleveland, Ohio. The five-room hotel and adjacent cottage was staffed by a cook and a housekeeper. The hotel had an upstairs lounge called the Miramar. During World War II, the Coast Guard used the second floor as a lookout point. The hotel was torn down in 1974 to build the county's Ocean Inlet Park.

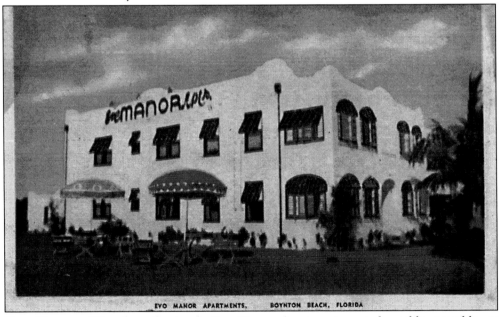

EVO MANOR. The elegantly simple Evo Manor Apartments rented weekly, monthly, or seasonally from November 1 to June 1. This *c.* 1930 image of the stucco building featuring Spanish Mission–style architecture has been hand-colored from a photograph. The advertisement on the back touts Evo Manor's "Picturesque and Quiet Surroundings" and that the hotel is "Beautifully Furnished."

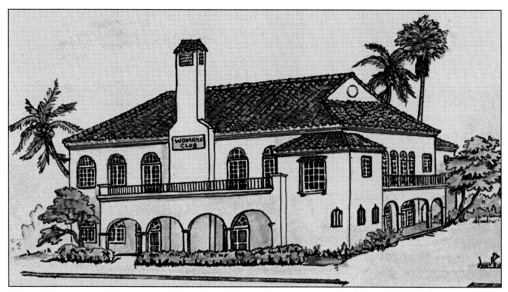

OUR NATIONAL TREASURE. Lorraine Keatts Gouge created this original drawing of the Boynton Woman's Clubhouse. The building is a memorial to the founder of the town, Maj. Nathan Boynton. The image is of the second Woman's Club building on South Federal Highway designed by Addison Mizner and built by Heaton and Adams in 1925. This local treasure was placed on the National Register of Historic Places in 1979. The Boynton Beach Historical Society uses the notable building for meetings, and many couples choose to be married in the distinguished building.

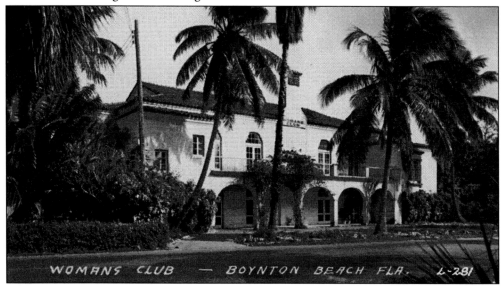

BOYNTON WOMAN'S CLUB. In 1908, a group of civic-minded women organized to erect a multi-purpose civic building for the town. Through a series of community fish fries, bake sales, and other fund-raisers, they created the first Boynton Woman's Club on Ocean Avenue (not pictured). The original clubhouse was built from lumber washed ashore from the 1909 shipwreck of a Norwegian barkentine named the *Coquimbo*. The second, larger clubhouse continues to be a source of price to the community. The not-for-profit Mizner Foundation continues to raise monies for the building's upkeep.

34

Three

STAY AND VISIT AWHILE

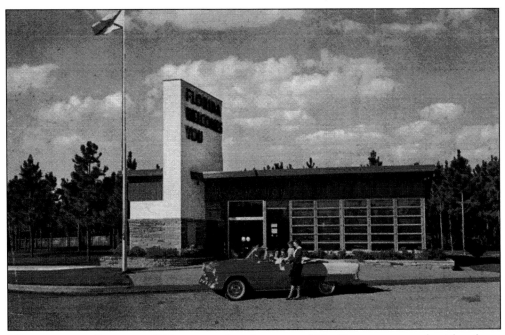

WELCOME TO FLORIDA. Visitors entering the state of Florida were greeted with a large welcome sign and an invitation to come inside and have a refreshing taste of Florida orange juice. The three-ounce cups of reconstituted concentrate of orange juice were as popular as these friendly welcome stations. Maps, postcards, and brochures for area attractions were offered. Many people who stopped spotted their first palm tree and were excited to visit "The Sunshine State."

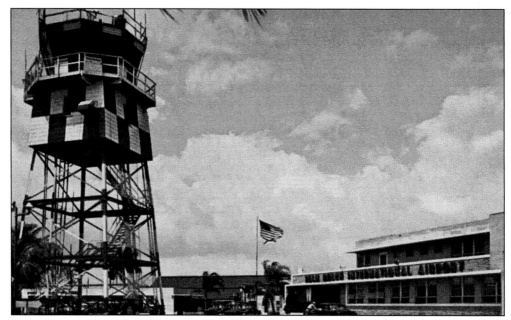

PALM BEACH AIRPORT. This was originally called Morrison Field after Grace K. Morrison, an early aviation pioneer. The field was dedicated and opened in 1936. Eastern Airlines was the first commercial flight carrier. Morrison Field was used exclusively by American troops in World War II and the Korean conflict. The airport opened a passenger terminal in 1947. To capitalize on internationally known Palm Beach, the name was changed to Palm Beach International Airport.

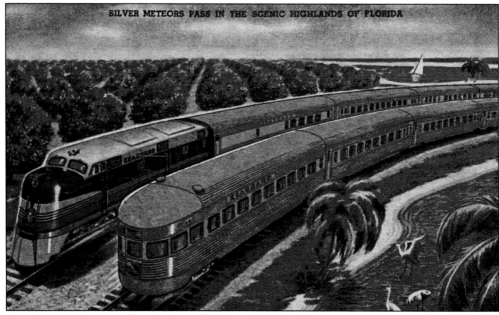

THE SILVER METEOR. Two Seaboard Railway trains pass in Florida's scenic highlands. Touted as the train of personal service, the Seaboard Railway's *Silver Meteor* was elegant and fast. The train featured stainless-steel coaches with modern sleeping cars, two dining cars, and three feature cars. A trip from New York to Boynton Beach took less than 24 hours.

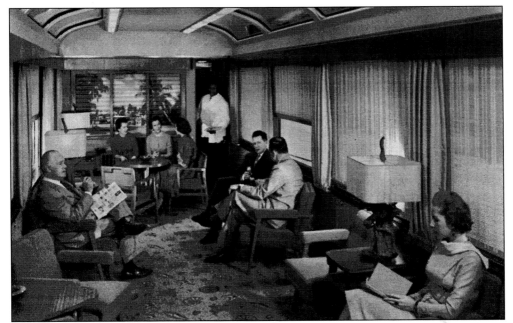

THE SUN LOUNGE. Passengers on the Seaboard Airline Railway relax in the parlor car. Notice the sunlights and comfortable furniture in the lounge. The Seaboard Airline was first class in service, with train passenger agents, stewardesses, car attendants, and nurses aboard. The sleek locomotives and posh passenger cars rumbled past orange groves, rivers, lakes, and beautiful Florida foliage.

THE GABLES. This frame vernacular residence on East Ocean Avenue was built in 1919 of sturdy, Dade County pine by Jim and Stella McKay and later served as a winter tourist apartment house. This *c.* 1950s image reflects the changes made to turn the lovely home into a retreat for discerning clientele on quiet Ocean Avenue. The wide, open screen porches were closed in, and air conditioning was added. The home still sits east of the Schoolhouse Children's Museum.

BOYNTON LODGE. Alva Shook built and operated Boynton Lodge, the old tourist motel seen in this view. This motel, in the heart of Boynton at the corner of U.S. 1 and Lake Avenue (now Boynton Beach Boulevard), rented rooms and efficiencies by the day or by the week. The Boynton Lodge was razed in 2001 to make way for the new marina and condominiums.

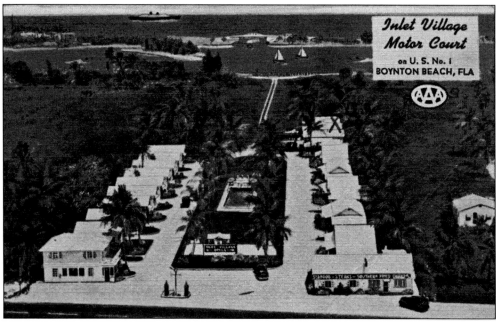

INLET VILLAGE MOTOR COURT. A *c.* 1940 postcard of the Inlet Village Motor Court reflects the easy-going lifestyle of vacationers and the reputation of Boynton Beach as a small fishing village. Guests could relax in their own private cottage, stroll through the delightfully landscaped grounds, play a leisurely game of shuffleboard, or launch a boat from the dock.

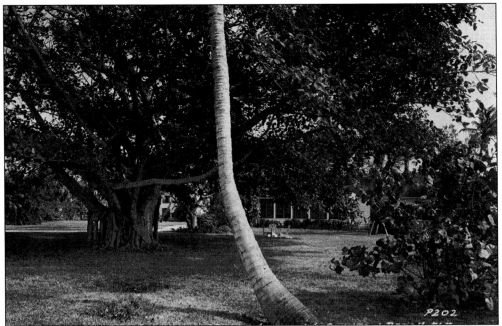

LEE MANOR INN. Boynton's first bed and breakfast inn is nestled among the sprawling Banyan trees. Lee Manor Inn, built from fine cypress and pine during the Great Depression, was owned by Mr. and Mrs. Roland Owens. This well-known 1931 landmark with exquisite gardens extending down to the Intracoastal was a retreat from the pulse of modern living. A period brochure describes the inn as "a haven for the discriminating traveler, not only comfortable lodging but delicious home cooked meals." The historic dwelling with the huge Banyans in front was still open in 2006 as the Pink Princess doll shop. (Bottom image courtesy Sheila Rousseau Taylor.)

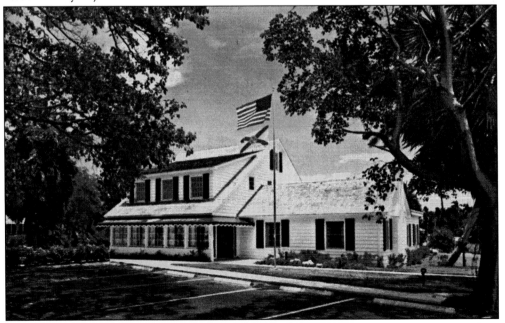

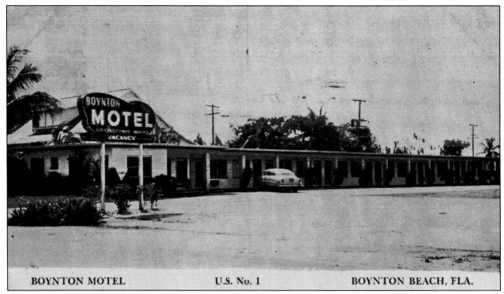

BOYNTON MOTEL U.S. No. 1 BOYNTON BEACH, FLA.

BOYNTON MOTEL. Both views are of the Boynton Motel on U.S. 1 in downtown Boynton, a two-minute drive to the beach. Tourists made annual pilgrimages to hotels or apartment rentals in Florida to idle away the cold, Northern winters. After the Great Depression, the Boynton area rebounded by offering cozy accommodations near the beach. The quiet town was perfect for tourists looking for a picturesque oasis with warm weather. The top card is postmarked May 10, 1954, and mailed from Fort Lauderdale to Chicago. Honeymooners Pat and Johnny write, "This was our Motel last night. We are 45 miles from Miami. We are taking our time so we can enjoy every minute of our honeymoon." To the left of the image, you can see the two-story Law Real Estate Building, still operating in 2006. The Boynton Motel was demolished in 2004 to make way for luxury townhouses.

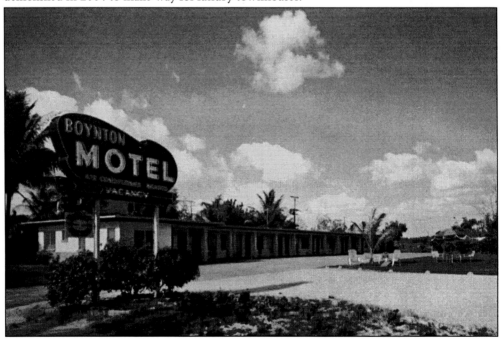

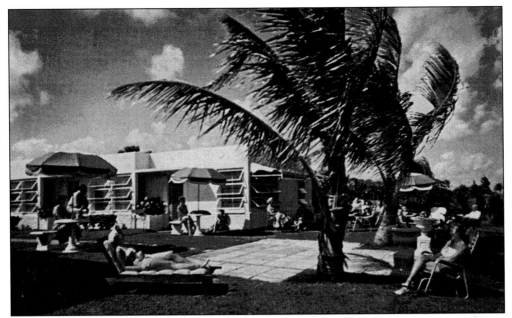

BEACH TERRACE APARTMENTS. Guests are shown enjoying the relaxing atmosphere of the Beach Terrace Apartments. Located south of Boynton in exclusive Highland Beach, these apartments typify the buildings constructed in our area during the 1950s and 1960s. The cement block structures, jalousie windows, and terrazzo floors make these apartments cool and comfortable inside all year long.

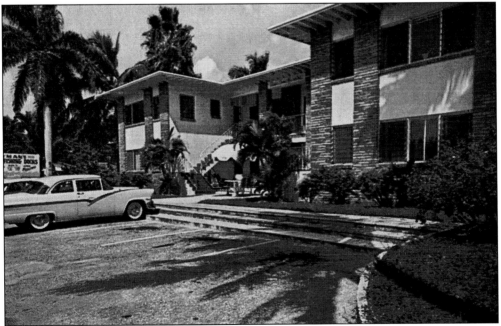

CASA LOMA MOTEL. Mr. and Mrs. E. Schwirring owned the Casa Loma Motel and Apartments, located on State Road 804 (Ocean Avenue) just down the block from the marina and fishing docks. The four-digit telephone number on the back of the card and the *c.* 1955 teal and white Ford with the wide whitewall tires suggest this card is from the mid-1950s.

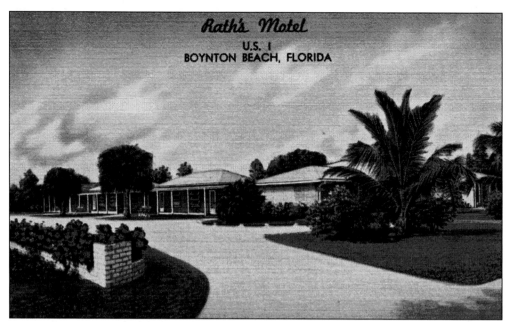

RATH'S MOTEL. This souvenir card shows beautifully landscaped Rath's Motel on south U.S. 1. The motel, owned by E. C. Geupel in the 1950s, offered modern efficiency apartments with a carport. U.S. 1, also known as Route 1, was the main roadway through South Florida before Interstate 95 came through in 1977. U.S. 1 parallels the East Coast of the United States for over 2,300 miles from Key West, Florida, to Fort Kent, Maine.

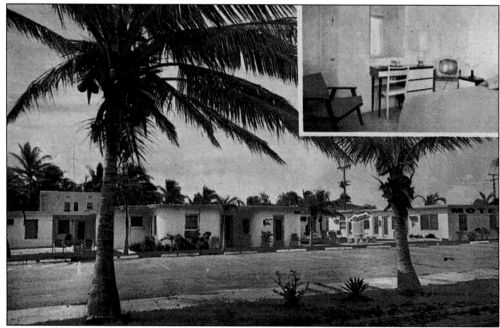

HANGGE MOTEL. The Hangge Motel, shown, was built in 1958 and was owned by Forest R. Hangge, a realtor who lived in Lantana. The small Boynton motel was located at 614 NE Eighth Avenue. In the 1960s, Boynton Beach had more than 20 motels operating within the city limits.

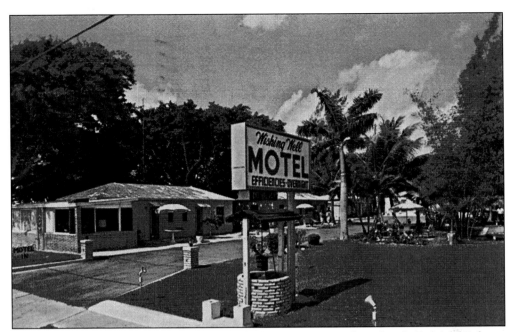

WISHING WELL MOTEL. This quaint, roadside Boynton motel on South Federal Highway promised "leisurely living only three minutes from golden sands and blue Atlantic." The motel offered shuffleboard, private patios, clean efficiencies, and hotel rooms. The replica wishing well caught the attention of travelers; families and honeymoon couples stopped to enjoy the fanciful atmosphere.

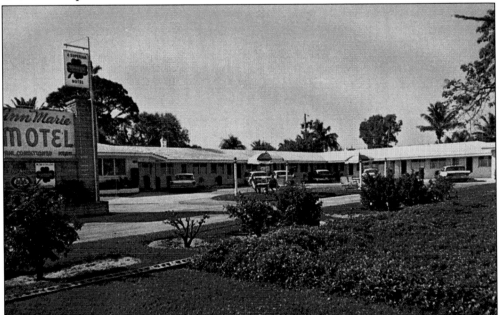

ANN MARIE MOTEL. Divided-back postcards, like this one from the 1960s, were left in the motel rooms for the guests to keep as souvenirs or to send to friends and relatives. This tiny roadside motel at 911 South Federal Highway, a staple in Boynton for many decades, was still open in 2006. The original owners were Mr. and Mrs. Salvatore Pandolfo.

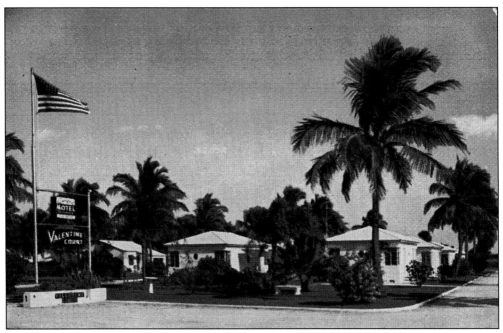

VALENTINE COURT. The motel on North Federal Highway faced Lake Worth (Intracoastal Waterway) and had a restaurant next door. In 1956, the 17 units, some with kitchenettes, rented for $10 a night and up in the winter. The summertime rate was $4 and up. Mrs. Leon Busiello was the owner/manager. The motel was torn down in the late 1990s and replaced by the Coquina Cove development.

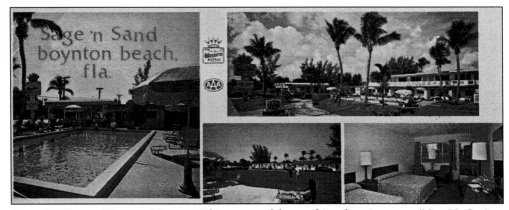

SAGE 'N SAND MOTOR HOTEL. This postcard bears this advertisement: "On U. S. 1 at Boynton Beach, Box 795, Florida, South Florida's most outstanding motel. Modern and smartly furnished. Swimming pool for our guests' relaxation and pleasure. Efficiencies with all electric kitchens, with accommodations for 4 guests. Coffee Shop on premises. Private parking. Short distance to public beaches and deep sea fishing. 'Your Winter Home in Florida.' Jim and Verdie Temple, Mgrs.—Owners."

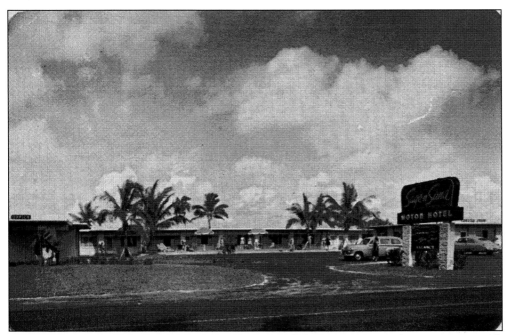

SAGE 'N SAND. Here are two more 1950s views of the AAA-approved motor court with landscaped patio, private pool, and shuffleboard court located at 1935 South Federal Highway. A franchise of the Best Western chain, and owned and operated by John and Margaret Sheppard, the Sage 'n Sand was known for the large pool and on-site restaurant, making the facility a big draw for the families visiting the area. Notice the undeveloped land and old water tower shown in the background of the lower image.

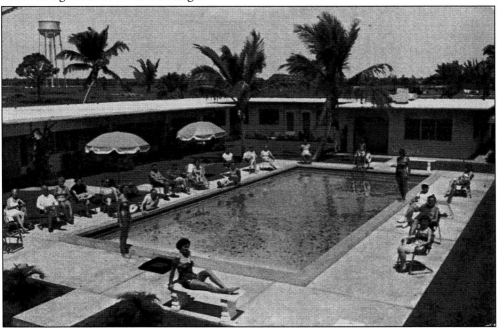

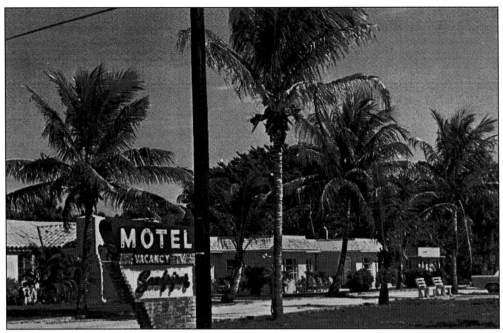

SANDPIPER MOTEL. Tall coconut palms line the grounds of the modest Sandpiper Motel in this 1960s advertisement. The motel features apartment cottages and motel rooms on the lake, directly across from the Boynton Inlet on U.S. 1. The inlet has long been promoted as the gateway to Florida's best sail fishing grounds.

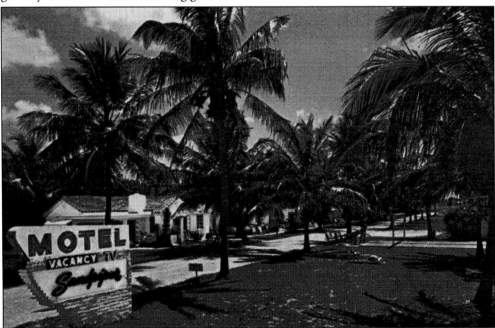

END OF AN ERA. In March 1997, the abandoned Sandpiper Motel, shown again in this 1950s view, was burned to the ground by the Boynton Beach Fire Rescue Department as part of a training exercise. The mayor, Jerry Taylor (serving his first mayoral term), the city commission, and many spectators turned out to see this slice of Old Florida go up in smoke.

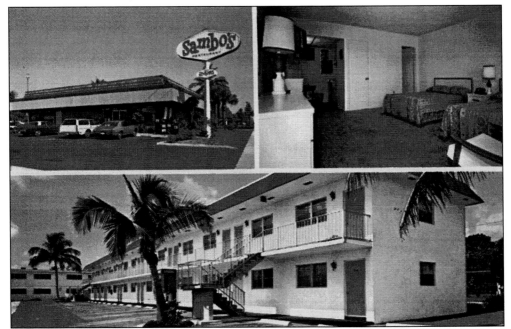

GOLDEN SANDS INN. This postcard shows three different views of the amenities at the Golden Sands Inn. The complex, built in 1973 and still in operation in 2006, is located on South Federal Highway. The advertisement on the reverse of the card highlights the many amenities and says the inn is right behind Sambo's Restaurant. Sambo's later became Denny's Restaurant.

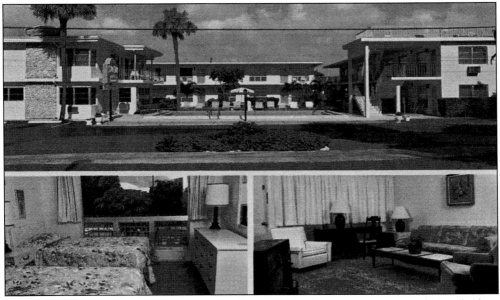

SUN-DECK RESORT. This resort located in Ocean Ridge (now apartment rentals) was built in 1960 on North Ocean Boulevard (A1A). It is part of the exclusive McCormick Mile subdivision, a mile of oceanfront land named for Robert McCormick of Chicago. The area is just north of today's Boynton Municipal Beach and just south of the current Ocean Club.

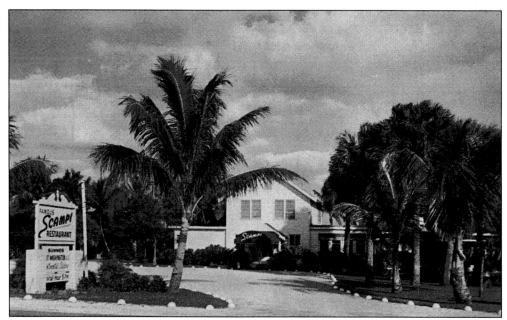

SCAMPI RESTAURANT. This delightful restaurant was owned and operated by Sam and Jean Grella and Frank Muzzi. It was the place to dine for famous celebrities and high society in the 1940s and 1950s. Prime steaks, double-cut lamb chops, chicken, veal, wonderful pastas, fresh seafood, and, of course, the famous shrimp scampi were on the menu. Scampi Restaurant was sold and became Tropical Acres in the 1960s.

TROPICAL ACRES. Tropical Acres Restaurant was located on U.S. 1 between Boynton and Delray. The Tabano family owned and managed this popular eatery that was famous for serving sizzling charcoal broiled steaks, chops, and chicken. With lively organ music and a cocktail lounge, Tropical Acres was a perfect setting for gracious dining. In 1962, a complete dinner of steak, chicken, chops, or seafood was advertised at $2.35 and up.

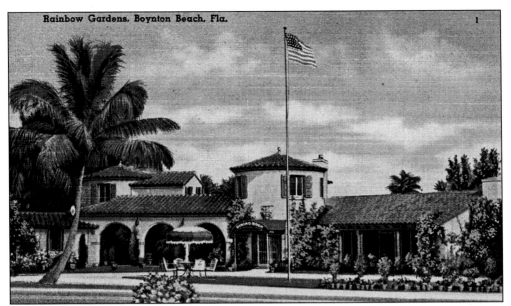

RAINBOW GARDENS RESTAURANT. Built in the late 1930s, the Mizner-inspired-style building at Rainbow Tropical Gardens contained a restaurant, refreshment stand, and a gift shop. Sightseers strolled under a cool canopy of foliage. Gaily dressed visitors traveled by boat via the East Coast Canal from Palm Beach and other places. The gardens were located where Benvenuto's restaurant is in 2006. The adjacent community of Via Lago houses some of the botanical gardens and uniquely carved pillars and stone seats.

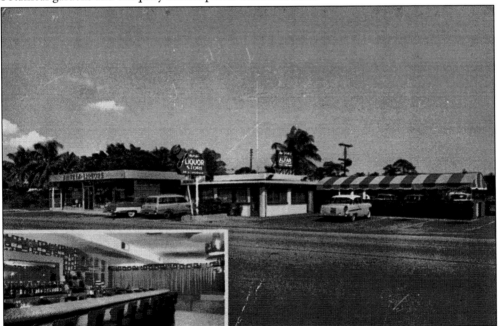

THE DUKE. The Duke Drive-In Food and Liquors on U.S. 1 at Lake Worth but within the Lantana city limits was famous for fine foods. With the famous "top-hat" trademark and the slogan "A Good Place To Eat," the Duke served a full menu including delicious seafood and steaks. It also had a cocktail bar and a package liquor store.

49

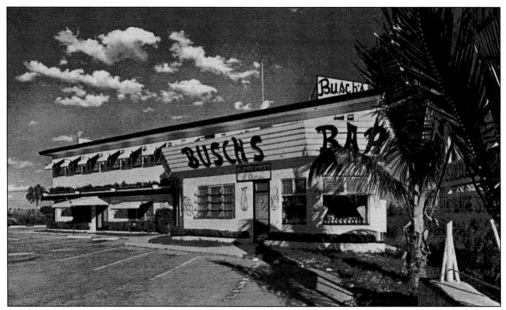

BUSCH'S BAR. This seafood restaurant in Ocean Ridge along A1A originated with the family of George and Anna Busch of Austria. George's brother Augustus joined the Anheuser brewery and became the Busch in Anheuser-Busch. The restaurant with an attached bar and package store was known for excellent seafood. Lobster, crab soup, scallops, shrimp, flounder, and deviled crabs were on the menu. The restaurant moved to a new location in Delray Beach in the 1980s. (Courtesy Sheila Rousseau Taylor.)

Lemon Meringue Pie
at
LUCILLE *and* **OTLEY'S**

MILE HIGH PIE. Lucille and Otley's restaurant was a fixture in Boynton for half a century, and this souvenir card touts their famous lemon meringue pie. Childhood sweethearts, Lucille Dickinson and Otley Scott opened their first restaurant on the beach after World War II. It was later moved to South Federal Highway and Southeast Tenth Avenue and served delicious food and memories to locals and tourists. The restaurant is now home to the Boynton Senior Center.

Four

A LIFE OF LEISURE

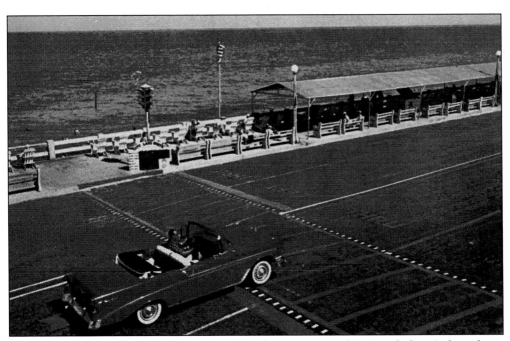

CRUISING. A South Florida tradition is to motor down State Road A1A with the windows down or convertible roof open. The Lake Worth beach, shown in this *c.* 1950s view, is an illustrious place to show off your new ride, meet friends, and admire the picturesque surroundings while out cruising on leisurely Sunday afternoons and hot weekend nights.

FLORIDA LIVING. For generations, South Florida residents and visitors have been attracted to the year-round sunshine, natural beauty, and slower pace of life. This card reflects our casual lifestyle. Notice the model's white shoes. White shoes were first manufactured to be sold in Palm Beach. Shoes used to be black, brown, or gray. A shoe store owner thought women would look more lovely wearing white shoes with their afternoon dresses. Soon gentlemen wore white shoes with their light suits.

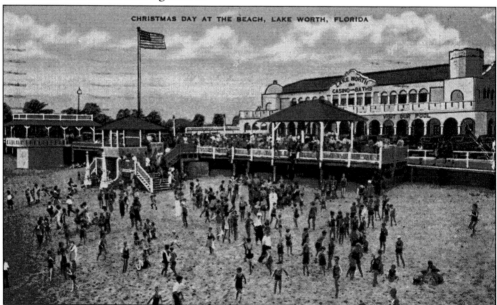

CHRISTMAS DAY AT THE BEACH, LAKE WORTH, FLORIDA

CHRISTMAS AT THE BEACH. This card, postmarked 1942, shows hundreds of bathers enjoying Christmas Day at the attractive Lake Worth Casino. The casino opened in 1922; gambling was legal until the mid-1930s. Pleasure seekers from miles around flock to the Casino where the ever-present Florida sunshine allows bathers, fishermen, and yachtsmen to take pleasure in beach activities nearly every day of the year.

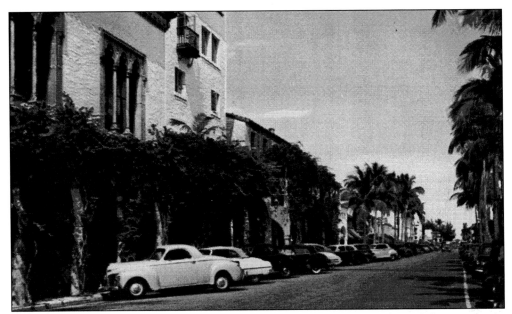

WORTH AVENUE. Fifteen miles north, on the island of Palm Beach, and famous for its international retail shops, Worth Avenue caters to the area's wealthiest residents and the fashionable guests at the Palm Beach hotels. Since the 1920s, saleswomen have acted as personal wardrobe costumers for customers. In the 1960s, Lilly Pulitzer launched her distinctive line of colorfully designed cotton outfits. Today Worth Avenue is a landmark destination for world-class shoppers and curious vacationers.

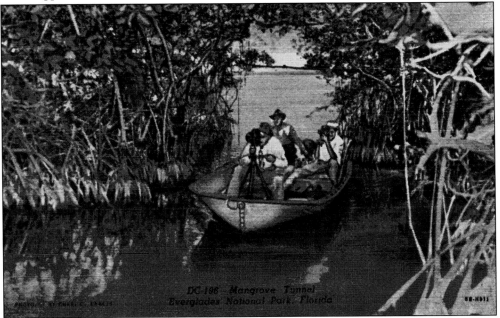

EVERGLADES NATIONAL PARK. Jungle cruise attractions have been popular on Florida rivers since the 1890s. This view shows a boatload of sightseers touring and photographing the natural jungle and unspoiled tropical beauty of a mangrove tunnel in Everglades National Park. Seen frequently on these cruises are alligators, deer, birds, otters, and raccoons.

WAITE BIRD FARM. Howard and Angela Waite ran this small roadside zoo on North Dixie Highway. The attraction was originally called the Lewis Bird farm before the Waite family bought it in 1947. As a result of the widening of Dixie Highway, the facility closed in 1960. Caring for exotic animals required patience and knowledge; consequently son Howard (Bud) became a veterinarian and a key force in establishing the Palm Beach Zoo at Dreher Park.

WAITE'S WILDLIFE. The bird farm in Boynton Beach included a pet shop. Dr. Bud Waite grew up on Waite Bird Farm with exotic animals, such as "Minnie," the pet baboon pictured on this postcard. He cared for the monkeys, alligators, macaws, flamingos, and parrots. Dr. Waite founded the Zoological Society of the Palm Beaches. He was also an artist who painted pictures of his beautiful birds. Some of his prints have appeared in *Florida Audubon Magazine.* (Courtesy Sheila Rousseau Taylor.)

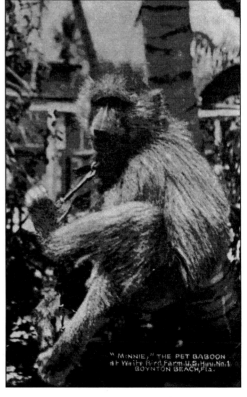

"MINNIE," THE PET BABOON
at Waite Bird Farm, U.S. Hwy. No. 1
BOYNTON BEACH, Fla.

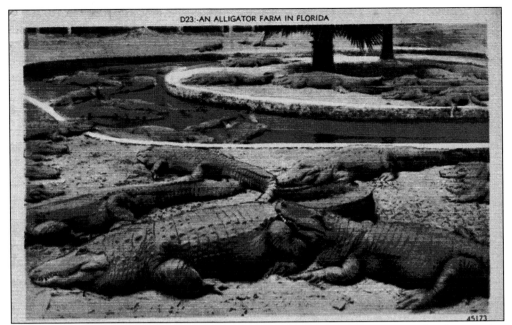

OSTRICH-ALLIGATOR FARM. Alligators are shown basking in the warm sunshine in a native beauty spot on an alligator farm. This alligator farm was one of many in southeast Florida during the early 20th century. The closest one to Boynton was the F. W. Anderson Ostrich-Alligator Farm and Zoo in Lantana. The popular tourist attraction featured birds, snakes, pythons, and alligators. Many of these wildlife farms closed at the start of World War II when tourism in Florida slowed. (Courtesy Sheila Rousseau Taylor.)

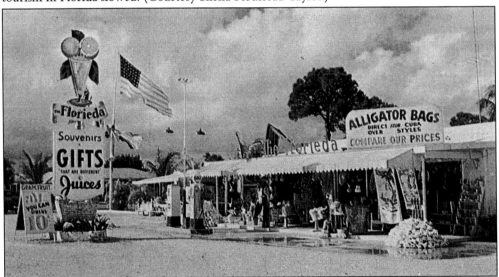

THE FLORIEDA GIFTS. Herschel and Frieda Hewitt ran this eclectic souvenir shop on South Federal Highway. The eye-catching sign featuring a colossal glass of grapefruit juice, and the deliberately misspelled name called attention to the roadside establishment offering all the grapefruit juice you could drink for a dime. Tourists stopped to buy gas from one of two fuel pumps and load up on beach towels, shell figurines, alligator bags, maps, cold drinks, and postcards. Stands like this were common on Dixie Highway. (Courtesy Sheila Rousseau Taylor.)

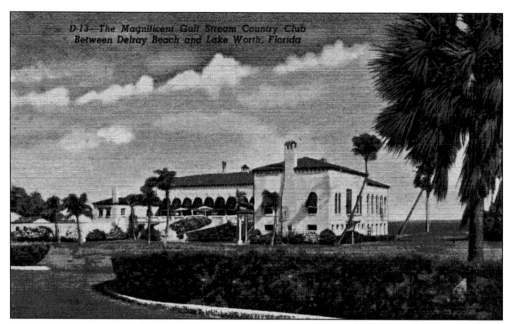

D-13—The Magnificent Gulf Stream Country Club
Between Delray Beach and Lake Worth, Florida

GULF STREAM CLUB. The Gulf Stream Golf Club opened in the winter of 1924, sporting lush landscaping and a Spanish Mediterranean–style clubhouse designed by Addison Mizner, designer of the Everglades Club in Palm Beach and the Cloisters in Boca Raton. Donald Ross, a renowned international golf architect, designed the golf course. Distinguished guests included Mr. Paris Singer.

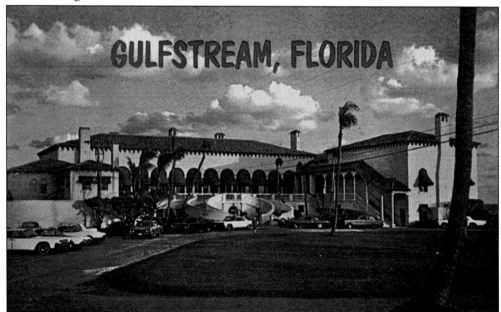

GULFSTREAM, FLORIDA

TOWN OF GULF STREAM. The lush homes sequestered behind the tall Australian pine trees that line A1A just south of Boynton Beach are part of the charming town of Gulf Stream, incorporated on May 12, 1925. This premiere private golf club has a legacy of being the finest original golf course in America. Gulf Stream was once nicknamed the "Winter Polo Capital of the World."

GOLF LINKS. This 1924 view shows the new golf course in Gulf Stream, Florida. The leisurely game of golf was conceived and propagated in Scotland. One of the first courses in the United States opened in 1916 at the Palm Beach Country Club. The new golf course superseded the esteemed Florida Gun Club, which had been known as the largest gun club in the United States. In 1951, there were only 14 golf courses in Palm Beach County.

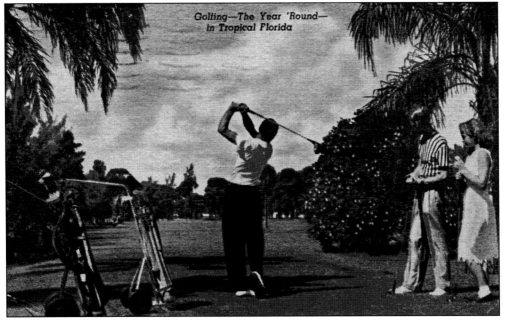

FORE! This postcard view shows a couple enjoying one of Palm Beach County's most popular pastimes, the game of golf. In the early days of golf in South Florida, ladies carried parasols to protect themselves from the scorching sun, and the men wore knickers. By the 1940s, sports attire like the casual outfits shown here were introduced to clothe the amateur players. In the favorable climate, golf is enjoyed year-round.

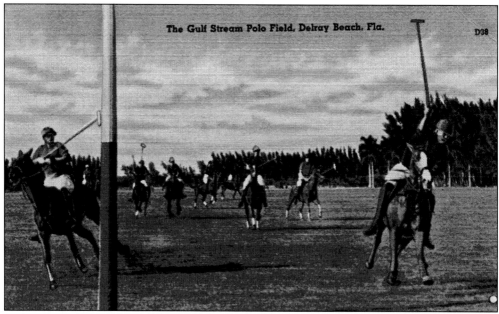

POLO GROUNDS. The Phipps family introduced high goal polo into Gulf Stream in 1923. By the end of the 1920s, Gulf Stream's reputation was firmly established as the "Winter Golf and Polo Capital of the World." On Sundays, more than 200 families traveled from Palm Beach by automobile or yacht to the club. Polo matches continued through the 1950s at the nationally known facility. Five fields, stables, and cottages were located between the present Little Club to the north and Golf View Road to the south. Gulf Stream School still uses some of the renovated and rebuilt stables.

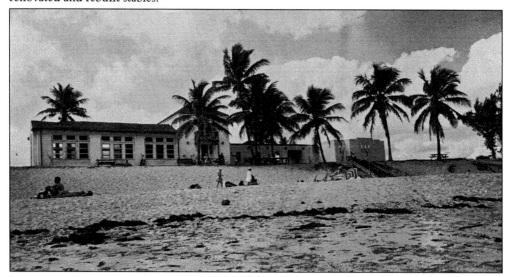

BEACHFRONT CASINO. In the boom days of the 1920s, the Addison Mizner–style structure of the Boynton Casino was erected. The facility has served many purposes. It was used as a recreational facility, as a restaurant, and for governmental purposes. The Ocean Ridge city council and other social and civic organizations met there. There was a snack bar, piped music, and a picnic area. This setting was a popular recreational spot for families to enjoy an ocean swim, an informal ball game, or a picnic barbecue.

RAINBOW GARDENS. Mr. and Mrs. Clyde O. Miller bought the 13 acres of land for Rainbow Tropical Gardens on North Dixie Highway about 1919. The landscaper owners created the famous landmark. Former names include the Garden of Eden, the Garden of Allah, and Rainbow Tropical Gardens. Once called an "artist's paradise" and the "cameraman's paradise," the stunning gardens of bougainvillea, azaleas, gardenias, and other flowering plants were interspersed with delicate arches, footbridges, gazebos, stone pathways, and a wishing well.

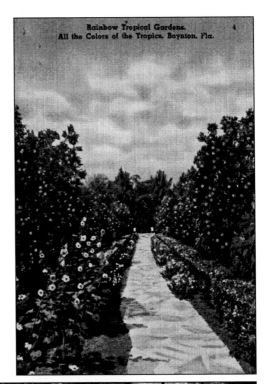

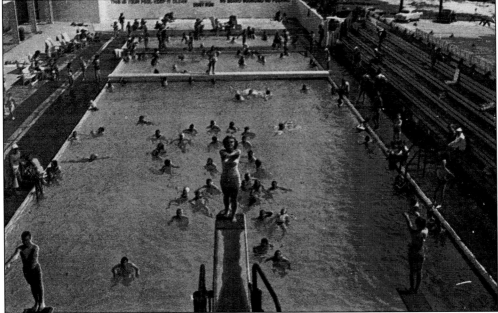

LAKE WORTH POOL. In the 1950s, Boynton kids were trucked to this pool at the Lake Worth Beach and Casino during summer vacations as part of the "Summer Recreation Program" at the old Boynton Elementary School. The pool was originally a saltwater swimming pool and in the 1950s was converted to a freshwater pool. In 1954, the landmark Lake Worth Pier, one of the longest municipal piers on Florida's Atlantic coast, was opened to the public. (Courtesy Cindy Lyman Jamison.)

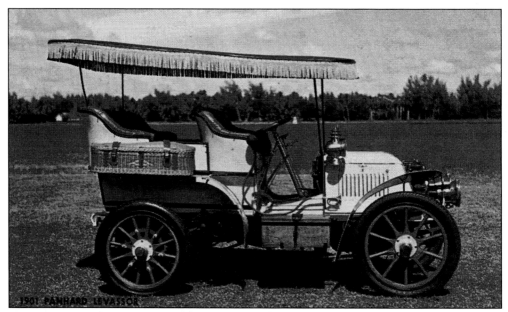

ANTIQUE AUTOMOBILES. James Melton opened the Autorama in 1953 along U.S. 1 just north of Boynton in Hypoluxo. Tourists and residents alike enjoyed the collection of well-kept rare automobiles, like this rare 1901 Panhard Le Vassor. You could get your photograph taken in some of the vintage automobiles, and rides were available for a modest cost. The attraction closed shortly after Melton's death in 1961.

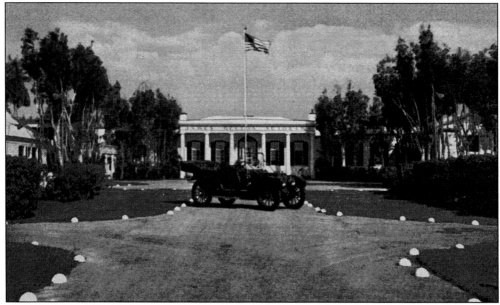

JAMES MELTON. Tenor James Melton appeared on radio, television, in movies, and with the New York Metropolitan Opera. Melton starred in a musical variety show, *Ford Festival*, on NBC in the 1950s. Melton collected and loved automobiles. He began the tradition of singing "Back Home Again in Indiana" at the Indianapolis 500. Speedway president Tony Hulman asked him to sing it on the spur of the moment in 1946. Melton put his collection on display in an Autorama, shown.

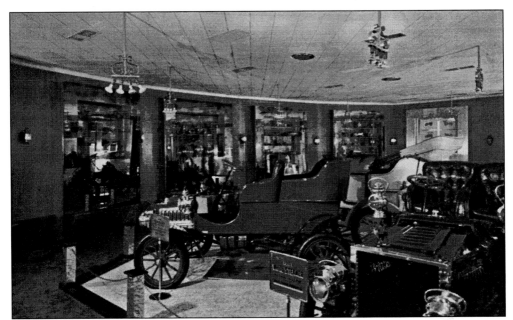

THE AUTORAMA. The Autorama attraction had a patio restaurant for visitors to have a bite to eat while on their excursion. There was a nice gift shop along with a Cyclorama with magnificent murals by world-renowned artist and Boynton resident Bernard Thomas. As a special attraction, James Melton hired local young women to dress in old-fashioned frocks to pose for photographs with tourists in the antique automobiles.

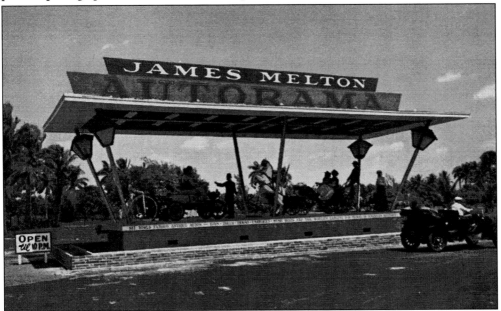

THE AUTORAMA MUSEUM. The James Melton Autorama boasted the world's finest private collection of antique automobiles and a collection of toys, music boxes, and baby carriages. Visitors marveled at the pristine cars. Local legend Bernard Thomas, known across the country, especially in the West for his murals and western scenes, painted the expansive Cyclorama *America The Beautiful*, illustrating great moments in American history.

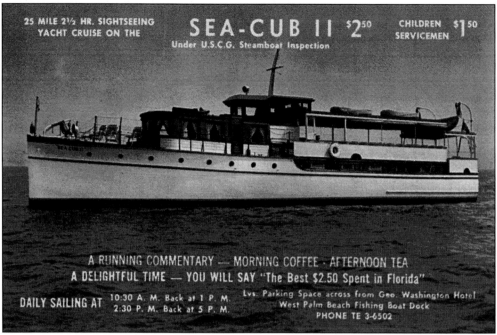

YACHT CRUISE. This postcard from the 1950s advertises a 25-mile, two-and-a-half-hour sightseeing cruise along the Intracoastal Waterway. For $2.50 per person, the cruise on the *Sea-Cub II* offered music, refreshments, and historical narrative. The commentary was said to be outstanding for its informative and entertaining value. Detailed information and amusing anecdotes were given about famous Floridians, including Henry Flagler, Paris Singer, Addison Mizner, and E. R. Bradley.

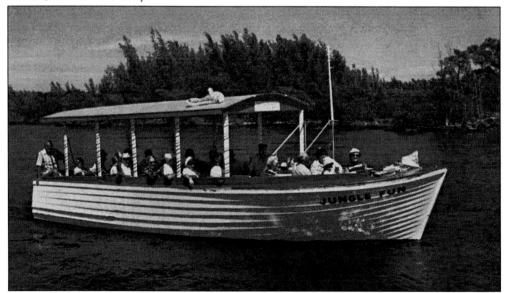

JUNGLE FUN CRUISE. This two-hour sightseeing cruise along the inland waterway left from the Sea Mist Marina. Captain Mace would entertain groups of tourists by pointing out various wading birds, describing the exotic flora and fauna, and talking about the voluminous mansions that were seen along the Intracoastal.

KNOLLWOOD GROVES. "Knolly" the orange was the mascot for Palm Beach's largest attraction, located three-and-a-half miles west of U.S. 1 on Hypoluxo Road. Wagon train rides, homemade fudge, juice tasting, and homemade pies were enjoyed for generations. Fruit was shipped throughout the United States and Canada. The gift store, snack bar, and packinghouse sat on what is today Lawrence Road and were surrounded by citrus groves and jungle hammock. Knollwood Groves opened in 1930 and closed in 2005 due to urban sprawl.

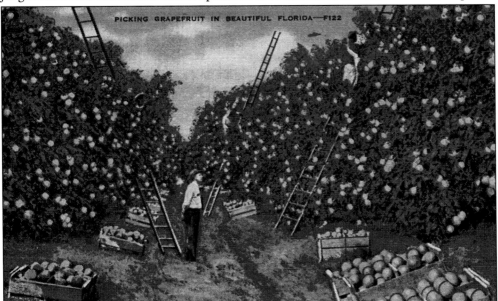

CITRUS FRUIT. Grapefruit, oranges, lemons, and limes have been grown in our area for over a century. The pioneers found a few groves already started when they arrived, and the Boynton Hotel land supported plentiful citrus groves. The delicate aroma of the blossoms sweetened the air, and the fresh, delicious fruits appealed to the winter visitors. Orange groves were a common sight in Boynton just a few decades ago. In areas not plagued with the citrus canker disease, homeowners still have backyard citrus trees.

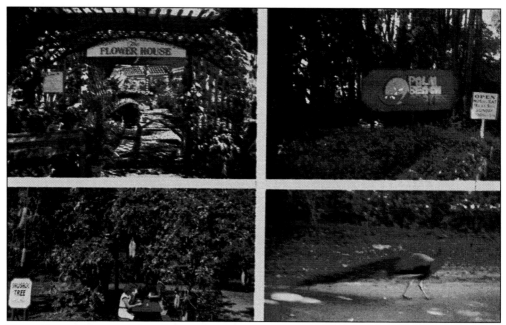

PALM BEACH GROVES. Another tourist attraction on Lawrence Road north into Lantana was the Palm Beach Groves. This delightful getaway amused visitors who purchased juicy citrus, freshly cut flowers, or homemade fudge. A canopy of native plants gave shade for relaxing with a picnic lunch. Birds like this striking peacock would strut by and delight the onlookers. The grove closed in 2004 due to development and urban sprawl.

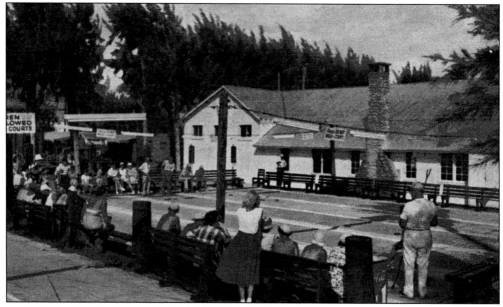

SHUFFLEBOARD COMPETITION. Shuffleboard is a favorite pastime at Briny Breezes Park. The signs in the background read "Please Do Not Walk On Courts" and "No Children Allowed On Courts." Postmarked February 1, 1957, the message from Madolin and Elmer to friends in New Jersey reports: "This is the way we look around here. It is wonderful. Temp 80–86 thru day. Door and windows open at night. We are learning to shuffle and it's fun. Bathing good."

WORLD'S TALLEST CHRISTMAS TREE. In 1961, Generoso Pope brought the *National Enquirer* headquarters to Lantana, and each year, from about 1970 until Pope's death in 1988, the *National Enquirer* grounds boasted the world's tallest Christmas tree. The beautifully landscaped grounds were a fantasy land of twinkling lights, the world's most unique model railroad display, a Nativity scene, and animated characters. Burl Ives sang at the first unveiling of the *National Enquirer* tree. Note the temperature of 76 degrees is displayed on the *National Enquirer* sign next to the Christmas tree.

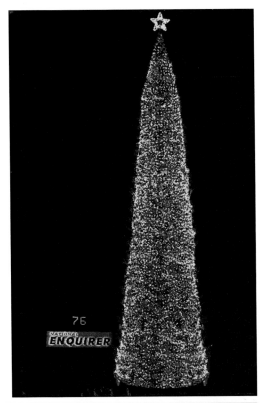

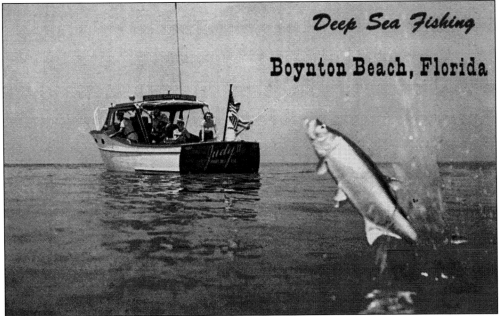

DEEP-SEA FISHING. Tourists loved to go out into the Atlantic Ocean to try their hand at deep-sea fishing. The sea captains knew the best places to hook enormous swordfish, sailfish, and the occasional shark. The experience of sailing in the open ocean waters and smelling the salty air had an exhilarating effect upon passengers.

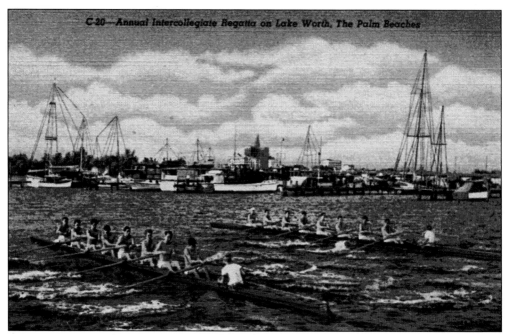

REGATTA. For nearly a century, the waters of Lake Worth (Intracoastal Waterway) have been the site of various boating regattas. Shown here are teams vying in the annual intercollegiate regatta of the Palm Beaches. The background shows a harbor full of expensive sailing ships.

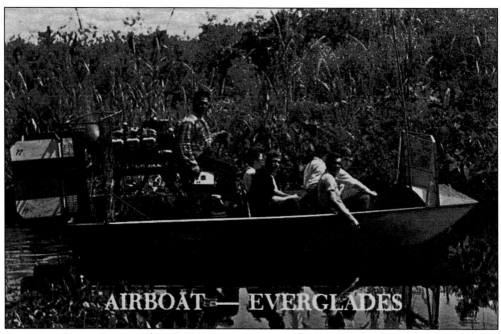

AIRBOAT ADVENTURE. This six-passenger airboat ride is one of many that allow paying customers to venture deep into the jungles of the Florida Everglades. The natives that operate these tours know their way around the true Old Florida. Wildlife and adventure await those who venture into the vast and silent Everglades on these high-performance airboats.

66

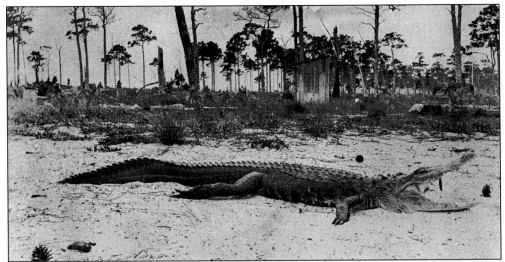

GATOR HUNT. Mailed to Mrs. F. W. Cunningham of Kingfisher, Oklahoma, this 1914 card shows an alligator hunted for sport. The terrain of pine scrub reflects Boynton at the time. The message reads: "My dear sister Gertrude: This is a gaiter which we caught in a big fish net. We sure had a fight with him. I left the nicest shells I found at Galveston and Key West, at Miama. May get time to hunt some real nice ones later. I have a good job for all summer at $42 per month and board if I want to. Love from your Bro, Grover." (Courtesy Henry Higgins.)

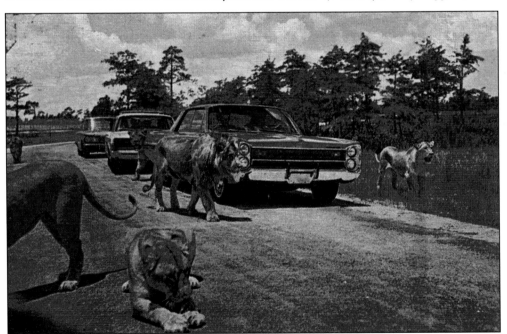

LION COUNTRY SAFARI. Since 1967, Lion Country Safari in western Palm Beach County has been attracting residents and visitors. This "cageless zoo," where wild animals roam free while tourists remain in automobiles, was developed by a group of South African and British entrepreneurs, allowing families to experience an African game park safari. Today the drive-through park and walk-through safari world are home to over 900 animals, including lions, white rhino, African elephants, chimpanzees, zebras, and giraffes.

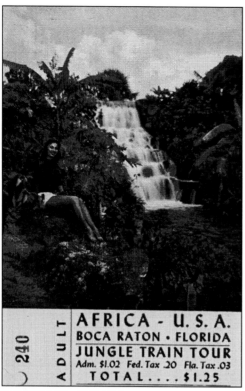

AFRICA U.S.A. This wildly popular attraction operated in Boca Raton from 1953 to 1961. John and Lillian Pedersen added 55,000 plants and an artificial waterfall to the 300 acres of jungle, which is now the Camino Gardens subdivision. Their son, Jack, traveled to Africa, returning with a modern-day Noah's ark of zebras, ostrich, cranes, wildebeest, and gazelle. According to a website that is run by Jack and Lillian Pedersen's granddaughter, Ginger Pedersen, at www.africa-usa.com, Africa U.S.A. is fondly recalled by many as the real Florida at its best—a little tropical, a little kitschy, and lots of fun for all who visited.

240) ADULT

AFRICA - U.S.A.
BOCA RATON • FLORIDA
JUNGLE TRAIN TOUR
Adm. $1.02 Fed. Tax .20 Fla. Tax .03
TOTAL.... $1.25

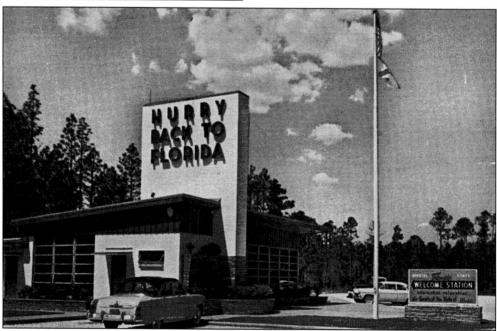

WELCOME STATION. This card is from another one of the kitschy Florida welcome stations that greeted visitors to the Sunshine State. If you took the time to stop at one of these popular roadside stands in the 1950s, you could drink all the orange juice you wanted for a dime and purchase souvenir seashells, saltwater taffy, and pecan pralines.

Five

THE NATURAL HABITAT

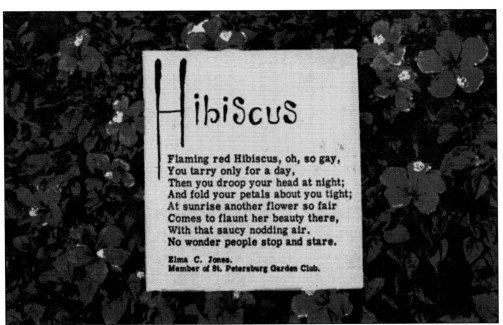

HIBISCUS. Postcards with pictures and poems paying tribute to the plants and animals of a region are common. This attractive card contains a poem with colorful flower background. The hibiscus is a shrub used as a hedge or background for other plants. The vibrant flowers of red, orange, yellow, white, or lavender last only a few days, but the flowering season is nearly year-round. Tropical hibiscus thrive in the southern half of the Florida peninsula.

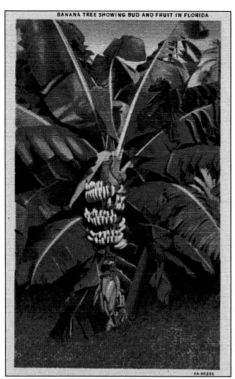

BANANA TREE. One hundred years ago, large banana trees, some reaching heights of 25 feet, were a common sight around Boynton Beach. The banana, a rapid growing herbaceous plant, is still grown on estates and in home gardens in South Florida. Banana plants are revered for both their ornamental value and their fruit. Varieties of bananas best adapted for our area are the dwarf variety cavendish, the apple banana, the lady finger, and the horse plantain.

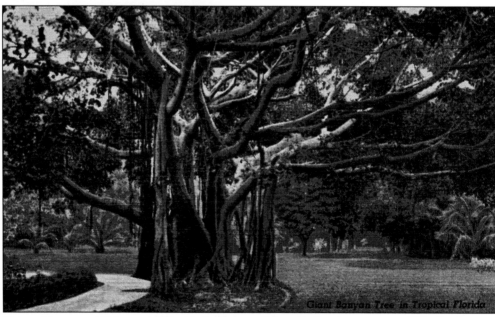

GIANT BANYAN. This area of Florida has many of these Indian banyan trees. The first banyan in the United States was planted by Thomas Edison in Fort Myers, Florida. Banyans are part of the tropical species ficus (fig) and have an unusual growth habit. The aerial roots grow earthward from horizontal branches, then thicken and cross over and take root into the soil next to the tree, creating a lattice of hanging roots around the tree. Banyans are sometimes referred to as Strangler figs.

70

PAPAYA TREE. Many homeowners cultivate backyard fruit trees of guava, mango, or papaya. Pies, jellies, jams, marmalade, chutney, and ice cream made from these tropical fruits continue to be a local delicacy. The seeds of the papaya are edible, and a delicious drink is made from the juice of the fruit. Papaya trees bear fruit when one year old. The creamy, white, fragrant flowers produce the most popular tropical fruit in the word.

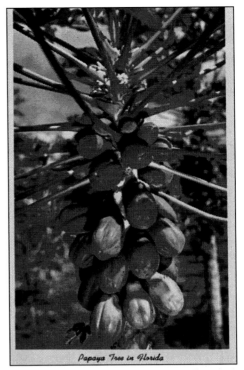
Papaya Tree in Florida

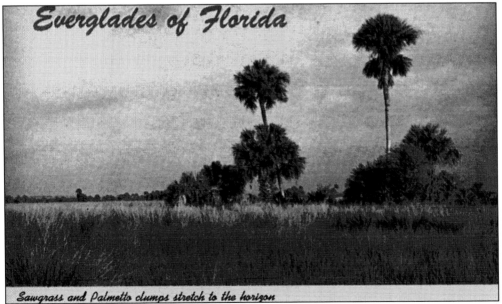
Sawgrass and Palmetto clumps stretch to the horizon

THE EVERGLADES. The Florida Everglades ecosystem is a national treasure. Once a vibrant, free-flowing river of grass, the system linked by water connects sawgrass, wet prairies, cypress and mangrove swamps, coastal lagoons and bays, sloughs, and tree islands. South of Boynton Beach is the Biscayne aquifer, which supplies 90 percent of southern Florida with drinking water. Most of the Everglades is gone, drained for agriculture and development. The Arthur R. Marshall Loxahatchee National Wildlife Refuge allows visitors to step back in time and glimpse Florida as nature created it.

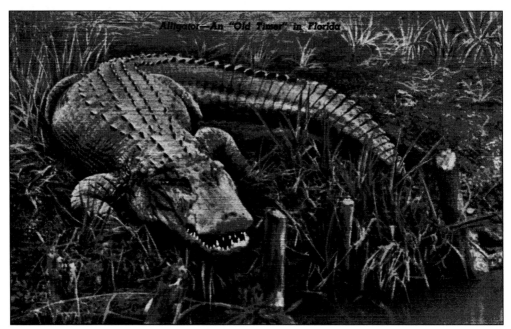

THE FLORIDA ALLIGATOR. Alligators are found in almost every body of water in Florida, and this nocturnal crocodilian lives in our many lakes, ponds, canals, and rivers. Alligators have good hearing and see best at dusk. The gators are hunted for their meat and hide. Laws have been enacted to protect the alligator. These days, a hunter needs a permit to hunt an alligator.

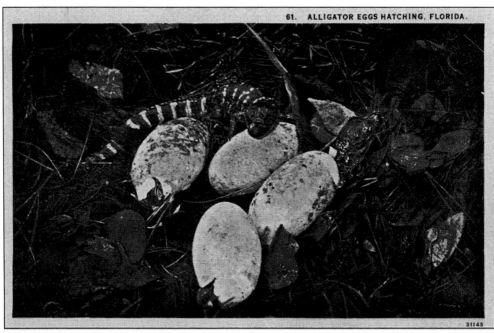

HATCHLINGS. Alligators mate in the warm spring weather. The female builds a nest of natural sticks, mud, and vegetation. She will be extremely defensive of her nest to predators. Alligators tend to lay about 40–50 eggs, and they have an incubation period of 65 days. The hatchlings are about six inches long.

SEA TURTLES. Herds of giant sea turtles crawled from the surf during the spring and summer and dug holes in the sand in which to lay their cache of eggs. Of marine turtles, the Loggerhead turtle, shown, is the most common to the area's beaches. The average size for mature Loggerhead turtles is 36 inches across with a weight of 350 pounds. The tiny hatchlings measure less than two inches.

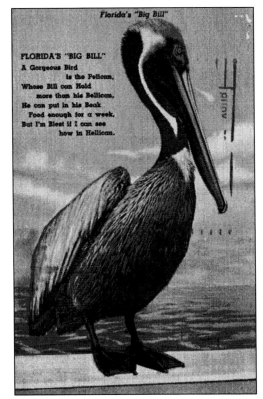

Florida's "Big Bill"

FLORIDA'S "BIG BILL"
A Gorgeous Bird
 is the Pelican,
Whose Bill can Hold
 more than his Bellican.
He can put in his Beak
 Food enough for a week,
But I'm Blest if I can see
 how in Hellican.

THE AMERICAN PELICAN. Along the coast and near the fishing docks, you will find large brown pelicans patiently biding their time and gracefully swooping down for a tasty fish from the Intracoastal Waterway or the Atlantic Ocean. When the boats come in with their catch, the pelicans hover nearby knowing that any leftover fish parts will be tossed into the water.

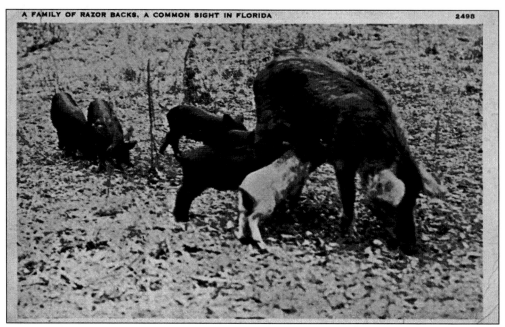

RAZORBACK HOG. The Florida razorback hog can grow as long as eight or nine feet and weigh almost a half a ton. The swine, brought over by explorer Hernando de Soto during the 1550s, evolved out of a system of free-range farming and have thick wiry hair all over their bodies as well as tusks for foraging and self-defense. Early settlers hunted the boar and used the meat for bacon and hearty stews. These days, you might see wild boar running free in western areas out near the turnpike, north of Palm Beach County.

PALM-LINED SHORE. Palm trees line this attractive stretch of golden, sandy beach. Swimmers and sunbathers benefit from the year-round sunshine and prevailing winds, which sweep over the Gulf Stream.

74

THE SEAHORSE. This type of postcard, popular with tourists and children, features a whimsical seahorse poem. Seahorses are not legends; they are real exotic marine creatures and range in size from 1.5 to 14 inches. These vertebrae fish can change color, have lizard-like eyes, and primarily are used for medicines and aphrodisiacs in Asia. They are also used for aquariums, curios, and food all around the world.

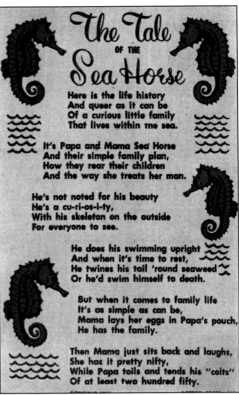

The Tale OF THE Sea Horse

Here is the life history
And queer as it can be
Of a curious little family
That lives within the sea.

It's Papa and Mama Sea Horse
And their simple family plan,
How they rear their children
And the way she treats her man.

He's not noted for his beauty
He's a cu-ri-os-i-ty,
With his skeleton on the outside
For everyone to see.

He does his swimming upright
And when it's time to rest,
He twines his tail 'round seaweed
Or he'd swim himself to death.

But when it comes to family life
It's as simple as can be,
Mama lays her eggs in Papa's pouch,
He has the family.

Then Mama just sits back and laughs,
She has it pretty nifty,
While Papa toils and tends his "colts"
Of at least two hundred fifty.

A Florida Beauty Spot.

FLORIDA THE BEAUTIFUL

On the shores of Florida
 The sweetest breezes blow,
'Tis here the fairest flowers bloom,
 The brightest sunsets glow.
'Tis here in sweet tranquility
 And balmy summer air
That we are free from frost and storm
 And wintry care.

A Florida Golf Course.

ODE TO FLORIDA. This pretty image shows typical Florida inland canoeing and recreational golfing scenes. A special touch on this postcard is the descriptive little poem about the beautiful state of Florida.

CANOPY OF PINES. State Road A1A officially opened in 1916 in the area of Manalapan, Hypoluxo, Ocean Ridge, Boynton Beach, Briny Breezes, Gulf Stream, and Delray Beach and is one of the earliest, most scenic, and most important north-south highways in Palm Beach County. In the 1920s, Australian pines were planted on both sides of the road in South Florida, up to the freeze line, to act as a windbreaker. Being a fast-growing species, a canopy over A1A soon developed, adding greatly to the beauty, charm, and character of the area.

SCENIC HIGHWAY. Much of the landmark, shady canopy has been destroyed, with the exception of what remains in Gulf Stream. The once desirable Australian pines are not as welcomed in some areas as they once were. In 1992, North Ocean Boulevard (State Road A1A) in the town of Gulf Stream was designated as a State Historic Scenic Highway to preserve the last remaining Australian pine canopy and the original character and beauty of the 1920s A1A in Florida. The Town of Gulf Stream has protected the canopy and has obtained authority from the state to restore it. (Courtesy Sheila Rousseau Taylor.)

Six

THE TOWN GROWS

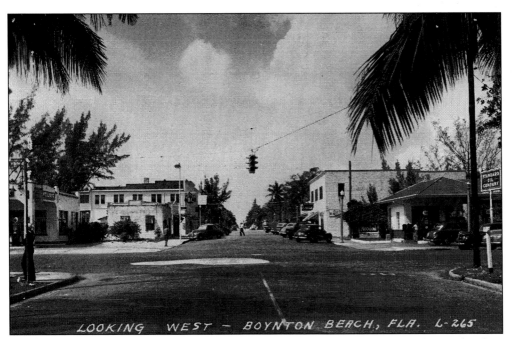

LOOKING WEST — BOYNTON BEACH, FLA. L-265

DOWNTOWN. The town of Boynton continued to grow, and this 1940s view shows a bustling downtown shopping area. The image shows the intersection of Ocean Avenue and Dixie Highway, looking west. The vicinity had come a long way since the days of residents living in tents amid palmetto scrub. Soldiers returning home from World War II discovered the small town located only 50 miles north of Miami. More and more people came here to work, live, and play. (Courtesy Boynton Beach Historical Society.)

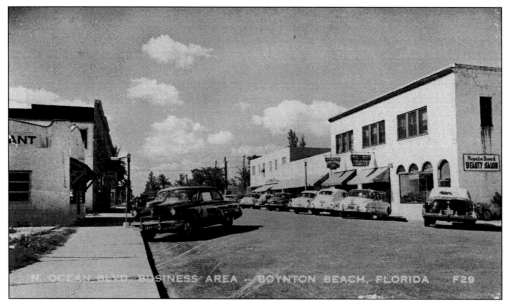

BUSINESS AREA. This postcard shows the business area of Boynton Beach. The business district was located along Ocean Avenue and along Federal Highway. The town was named after its founder, Maj. Nathan Smith Boynton. Over the years, part of the town's name changed. In 1939, the town of Boynton Beach changed its name to Ocean Ridge. Within two years, the town of Boynton also adopted a new name and became the town of Boynton Beach. (Courtesy James T. and Bernice Miner family.)

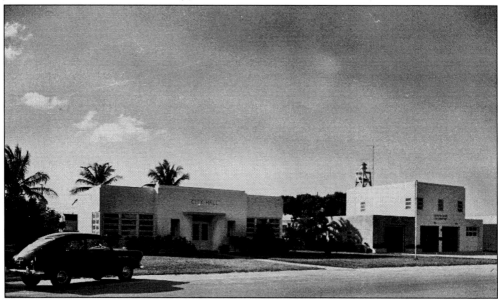

CITY SERVICES. This City of Boynton Beach municipal complex on the west side of North Federal Highway consisted of city hall, the fire station, and the police station. The police department was established in 1920. The first police marshal, Fred Benson, patrolled the town by bicycle. The fire department, established in 1924, had only two paid members in 1953. A new city hall complex opened on Boynton Beach Boulevard and Seacrest Avenue in 1956. (Courtesy James T. and Bernice Miner family.)

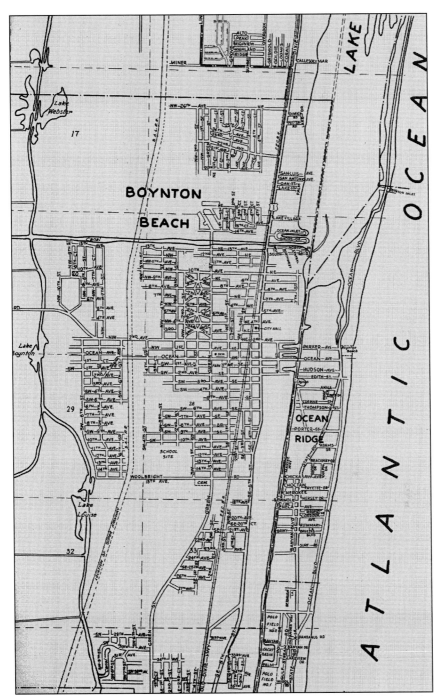

CITY MAP. The Boynton Beach Chamber of Commerce offered this *c.* 1954 map of Boynton Beach. Boynton's population was less than 3,000. The main east-west roads at that time were Miner Road, Northwest Second Avenue, Ocean Avenue, and Woolbright Road. Northwest Second Avenue (now Boynton Beach Boulevard) was the only road to run west to Congress Avenue. The north-south roadway strip labeled "Location of Super Highway" opened in 1977 as Interstate 95. (Courtesy Boynton Beach Historical Society.)

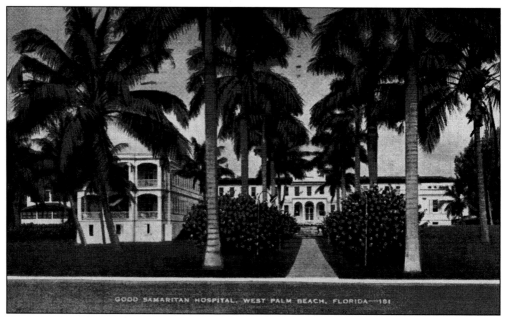

GOOD SAMARITAN HOSPITAL. This postcard mailed in 1948 shows Good Samaritan Hospital on beautiful Lake Worth in West Palm Beach. The hospital at 1309 North Flagler Drive opened in 1945, serving residents throughout Palm Beach and the Treasure Coast. Good Samaritan's forerunner, the Emergency Hospital, was founded in 1914 in a modest five-room cottage. Today Good Samaritan is known as Good Samaritan Medical Center.

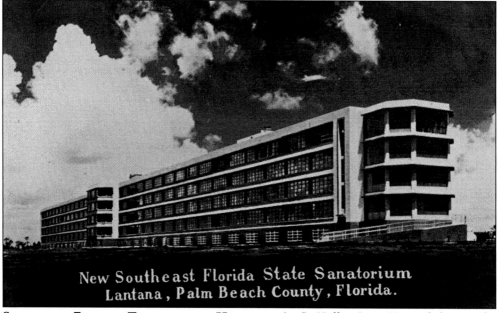

New Southeast Florida State Sanatorium
Lantana, Palm Beach County, Florida.

SOUTHEAST FLORIDA TUBERCULOSIS HOSPITAL. A. G. Holley State Hospital, known for its streamlined, modern, art deco design, opened in 1950 in neighboring Lantana. Originally the hospital had built-in facilities for doctors and staff and was one of four state hospitals built during through the 1950s to treat tuberculosis. A. G. Holley is the last of the original American sanatoriums that continues to be dedicated to tuberculosis.

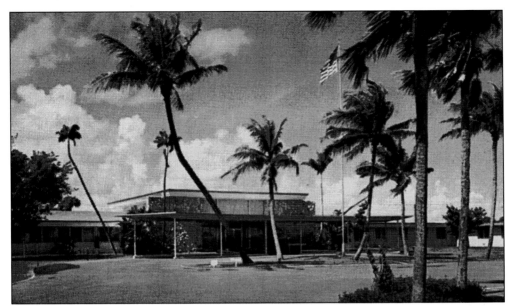

BETHESDA MEMORIAL HOSPITAL. Boynton Beach's first and only hospital, Bethesda Memorial, admitted the first patient in 1959. The hospital had 32 doctors on staff, 65 employees, and 70 beds. Bethesda Memorial Hospital was named for the healing pool of Bethesda, which according to the Bible was a pool in Jerusalem near a sheep market that healed those who walked into it. The hospital has a rock taken from ruins said to be those of the actual pool.

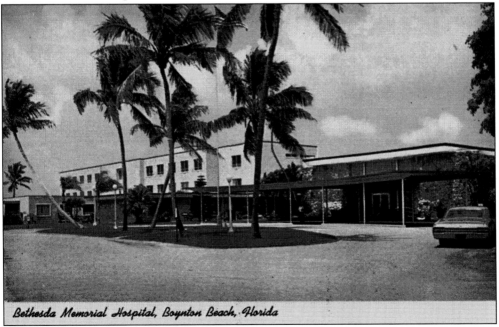

Bethesda Memorial Hospital, Boynton Beach, Florida

THE HOSPITAL GROWS. In 1963, Bethesda Hospital doubled capacity, and in 1966, second and third floors were added. The not-for-profit hospital has grown extensively through generous contributions from the community. Since 1986, a new Center for Radiation and Oncology as well as Bethesda Health City have opened to serve the growing population. Most recently, the Heart Institute opened. Bethesda Memorial Hospital has many devoted volunteers.

BOULEVARD MANOR. This attractive, contemporary 110-bed skilled nursing center was brand-new in 1963. Touted as a beautiful resort setting with continuous quality care provided by a totally professional staff, Boulevard Manor was the first of many nursing facilities to spring up to care for residents. Boulevard Manor is located on Seacrest Boulevard just south of Bethesda Memorial Hospital.

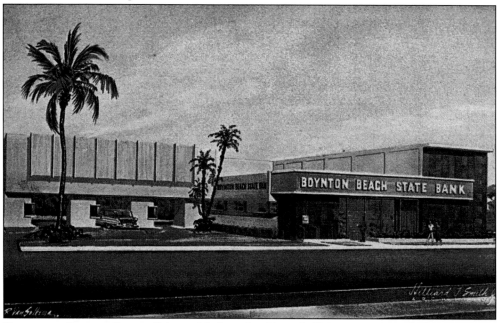

BOYNTON BEACH STATE BANK. Modern banking facilities were provided to Boynton Beach residents and visitors at the Boynton Beach State Bank, pictured. The bank opened in 1948 and moved into this contemporary facility with drive-up features in June 1953. The former bank building at 115 North Federal Highway now houses the Boynton Beach Congregational Church.

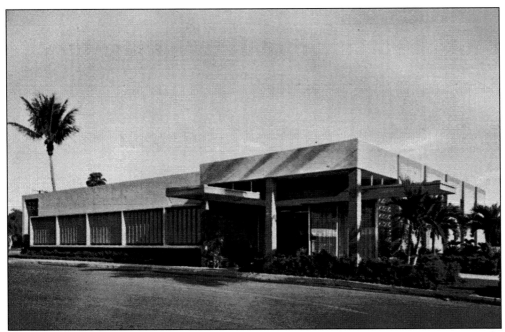

FIRST FEDERAL SAVINGS. In 1937, the First Federal Savings and Loan Association opened in Lake Worth. This postcard is from a 1960 promotion for the brand-new contemporary Boynton Beach branch at 901 South Federal Highway. In 2006, the bank building, featuring drive-though banking service, was still open as a local branch of Washington Mutual Bank.

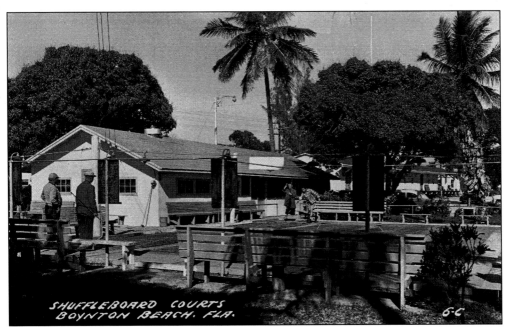

SHUFFLEBOARD. The city shuffleboard courts, shown, have been a source of pride for the city and a pleasure for residents. Shuffleboard was and still is very popular in Florida. With the city's average temperature being 76 degrees, the game can be played all year-round.

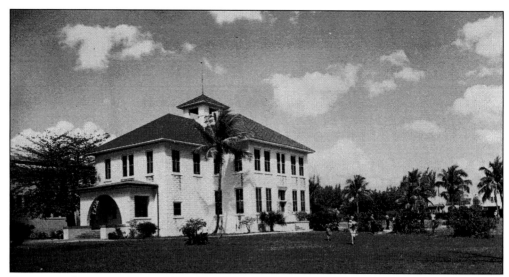

BOYNTON SCHOOLHOUSE. The new Boynton School opened on September 8, 1913, with 81 students, the largest enrollment yet in the town's history. Despite some necessary changes over the years, the school building retains much of its original fabric and character. In 1994, the building was listed on the National Register of Historic Places. In 2001, it opened as the Schoolhouse Children's Museum, a premiere history museum for children and families to learn about their rich South Florida heritage. (Courtesy James T. and Bernice Miner family.)

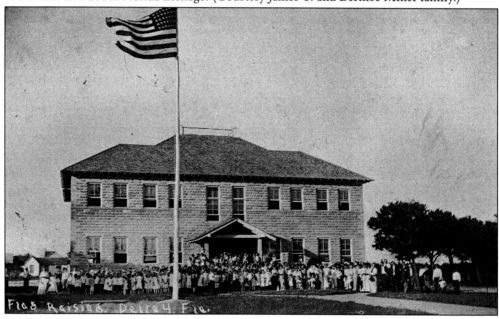

DELRAY SCHOOLS. This picture postcard shows the 1913 Delray Elementary School at Atlantic Avenue and Swinton Avenue. Delray High School was constructed next door on the same site in 1925. Delray High's last class graduated in 1949. The buildings housed a growing population of elementary students. In 1988, the Delray schools were placed on the National Register of Historic Places, and Old School Square, comprised of the Cornell Museum, the Crest Theatre, a refurbished gymnasium, and an outdoor entertainment pavilion, was formed. (Courtesy Sheila Rousseau Taylor.)

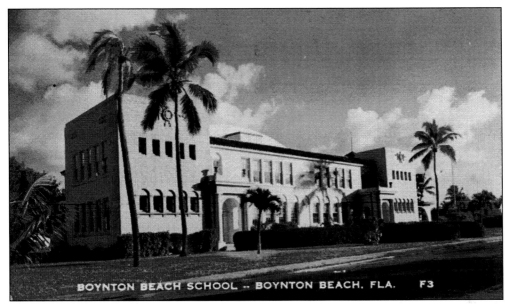

BOYNTON HIGH SCHOOL. This two-story high school was built in 1926 to keep up with the city's boom-time growth. The Mediterranean Revival–style school includes a large second-floor gymnatorium. The building features decorative spiral columns, cast-concrete base moldings, recessed arches, and ornamentation in the form of the crest and torch motif embellished with stylized ribbon. The school mascot was the tiger, and school colors were gold and black. After 1949, the building was used as a grammar school. (Courtesy Sheila Rousseau Taylor.)

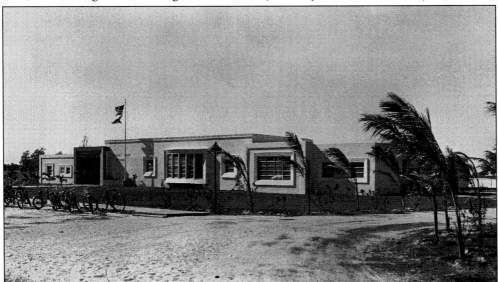

FOREST PARK SCHOOL. Forest Park Elementary School, built in 1955, is shown here. Most of the children who attended the school in those days lived in the immediate neighborhood and walked or rode their bicycles to the public school at SW Third Street and SW Eleventh Avenue. Notice the wide, barren area around the school. Interstate 95 did not go through the Boynton area at that time; Interstate 95 opened in Boynton Beach in 1977. In 2006, the Palm Beach County School Board planned to replace the school building at the same location. (Courtesy Boynton Beach City Library.)

SCHOOL INTEGRATION. After World War II ended, the population of both Boynton and Delray outgrew the existing school buildings; plans were drawn to build a new high school between the towns. The school shown was originally called Seacrest High School and then Atlantic High School after racial integration in schools resulted from the civil rights movement. The high school, in Delray Beach, served the communities of Boynton Beach, Delray Beach, and Boca Raton from 1948 until 1970.

SEACREST HIGH SCHOOL. The Seacrest mascot was the Seahawk, and the colors were green and white. In the 1960s, students enjoyed sock-hops and learned a new dance called the twist. The junior-senior proms were often held at the Boca Raton Cabana Club on the beach. A favorite hangout was a hamburger stand on Federal Highway called the Mug. In 1971, the school's name was changed to Atlantic High School. The school has received national notoriety for outstanding contributions in academics, football, and dance.

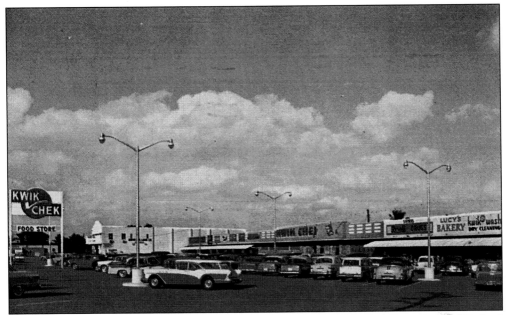

KWIK CHEK. By the late 1950s, strip malls like this one on the northeast corner of Federal and NE Second Avenue (now Boynton Beach Boulevard) were coming to life. This modern shopping center housed the Kwik Chek supermarket (later called Winn-Dixie), Lucy's Bakery, Belvedere Five and Dime, a barbershop, and other stores. The complex served the community until 2006, when it was demolished to make way for the Promenade.

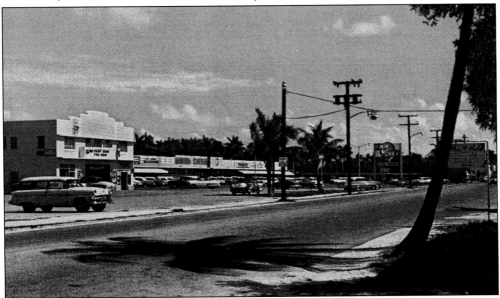

BOYNTON THEATRE. The Boynton Theatre at Lake (Boynton Beach Boulevard) and U.S. 1 is the building on the left. The town's movie theater originally featured silent movies, and an employee provided dramatic music on the piano. The building had one screen and wooden floors. For a quarter-dollar you could watch two features, a cartoon, and a newsreel. Popcorn was 5¢. Church groups met there before construction of their own buildings, and businesses occupied the theater's second floor. (Courtesy Sheila Rousseau Taylor.)

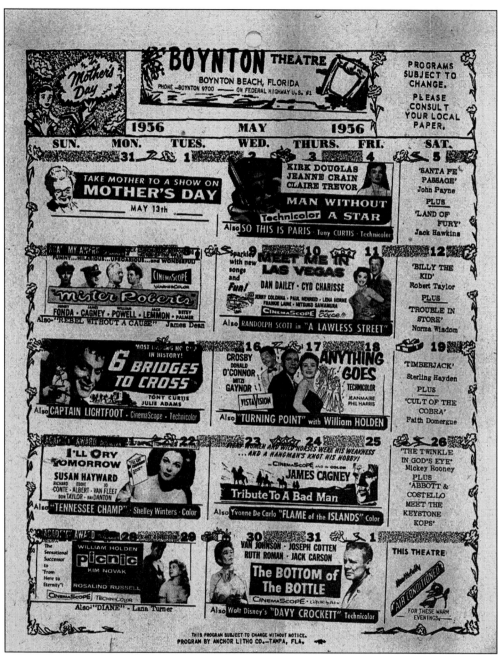

THEATER PROGRAM. Mother's Day weekend in 1956 at the moving picture theater included Kirk Douglas in *Man Without a Star* along with *So This is Paris* starring Tony Curtis. Other movies playing were *I'll Cry Tomorrow* with Susan Hayward; *Anything Goes* with Mitzi Gaynor; and *Mister Roberts,* a comedy with Henry Fonda, James Cagney, and Jack Lemmon. Youngsters enjoyed Walt Disney's *Davy Crockett.* This brochure states "the theater is healthfully air-conditioned for these warm evenings." (Courtesy Sheila Rousseau Taylor.)

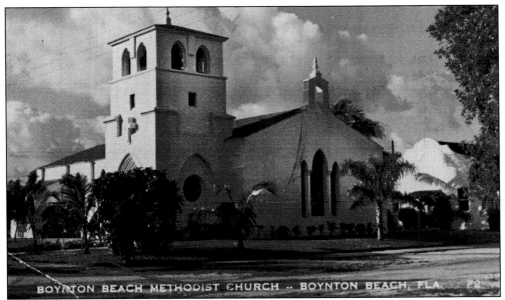

METHODIST CHURCH. In 1905, a congregation of 21 people organized the Boynton Methodist Episcopal Church South, which included Boynton and Delray. Services were held at the old schoolhouse. In 1908, a cement block "Corner Church" was built at Dixie Highway and Ocean Avenue. In 1926, a Methodist Tabernacle was built at Green Street and Poinciana (Seacrest Boulevard and NW First Avenue); it was destroyed in the 1928 hurricane. In 1930, this stylish church sanctuary was built; it later became the fellowship hall.

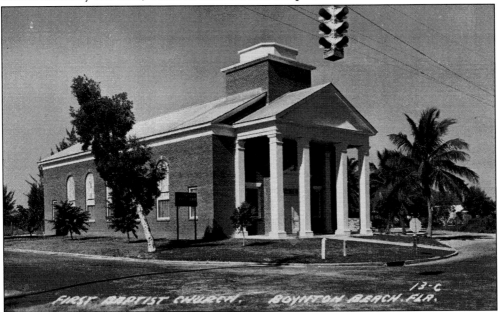

FIRST BAPTIST CHURCH. The Baptists established their first church building in 1925. For many years, it was located on the southeast side of Lake and Green Streets (names later changed to North Second Avenue and Seacrest Boulevard), where the present-day city hall complex is. In 1947, the church was relocated across the street to its current location at 301 North Seacrest Boulevard. In 2005, the campus was enlarged. (Courtesy Boynton Beach City Library.)

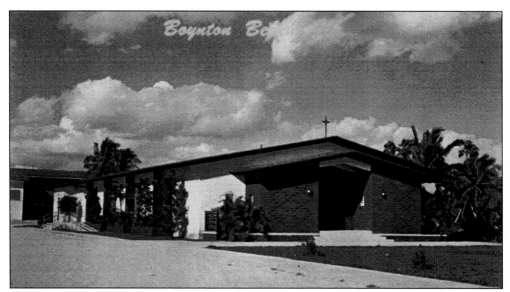

ST. MARK'S CHURCH. Situated on former farmland between the Intracoastal Waterway and Federal Highway is St. Mark's Catholic Church. The church pictured here was the home of the congregation for 50 years. The parish was started in 1952 and, like many area congregations, first met in the Boynton Theatre. The first pastor was Fr. G. J. Manning. A new church building was dedicated in 2004. St. Mark's Catholic School serves students in pre-kindergarten to eighth grade.

ASCENSION LUTHERAN CHURCH. One hundred sixty people attended the 1958 opening worship services in the Boynton Theatre with H. William Johnson, a mission pastor serving the charter membership of 63 families. This view shows the sanctuary of the Ascension Evangelical Lutheran Church on South Seacrest Boulevard, built in 1961. The church houses a Schantz pipe organ, handmade needlepoint cushions depicting Lutheran history, many stained-glass windows, and an altar formed from a solid block of coral. A new sanctuary was built in 1984.

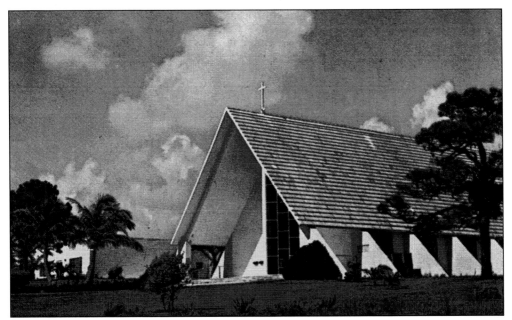

ST. JOSEPH'S CHURCH. Founded in 1954, St. Joseph's Episcopal Church sits upon one of the highest points in Boynton Beach. The beautiful buildings and grounds include an accredited college preparatory school for pre-kindergarten to eighth-grade students. The school has been in operation since 1958. The parish mixes the time-honored and venerable traditions of their rich, Anglican heritage with contemporary liturgical experiences.

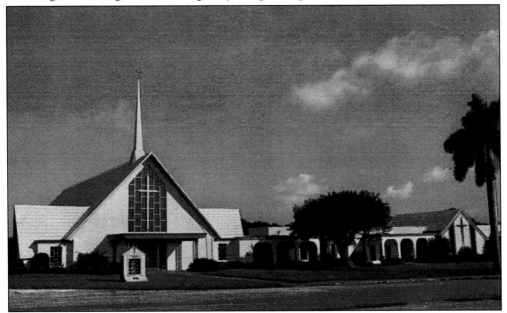

FIRST PRESBYTERIAN CHURCH. The First Presbyterian Church, built on a former mango grove, is situated in a residential neighborhood west of Seacrest Boulevard, a few blocks away from Forest Park Elementary School. Prior to building their own sanctuary in 1959, the church members held worship services in the Boynton Woman's Club. The congregation fosters a positive community spirit through their outreach contributions.

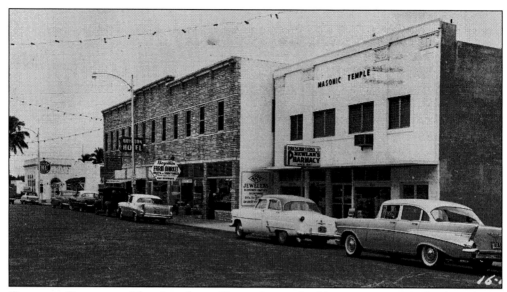

COME TO BOYNTON. The view shows Ocean Avenue looking east toward Federal Highway. The Masonic Temple and Newlan's Pharmacy are in the foreground. An excerpt from a *c.* 1950 handbill sponsored by Boynton citizens and merchants remarks, "Boynton life is just like life in your own 'home town' . . . with advantages of climate, school, congenial friends, and nearness to all the amusements to be found in the larger tourist centers. The best of theaters, restaurants and resort entertainment scarcely an hour away . . . and you don't have to live and try to sleep in the midst of that racket."

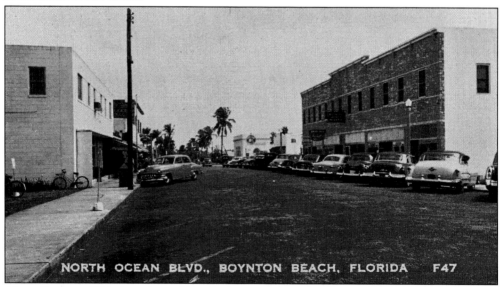

MAIN STREET. This is a view of North Ocean looking east from the FEC Railway station. The large, brick building was known as the Harrell Building or the 500 Building. Businesses included the Western Auto Store, Masonic Hall, Newlan's Pharmacy, U.S. Post Office, Boynton Hotel, Edgar Stationery Store, Boynton's Automatic Laundry, Haleys Refrigerator Sales, Harrell's Barber Shop, Yates Realty, Lou and Marty's Soda Bar, Harvey E. Oyer Jr. Real Estate and Insurance, the Shopper, and Kitching Chiropractic. In 2006, the south side of the street was razed for a new development. The only original business left is Oyer Real Estate and Insurance.

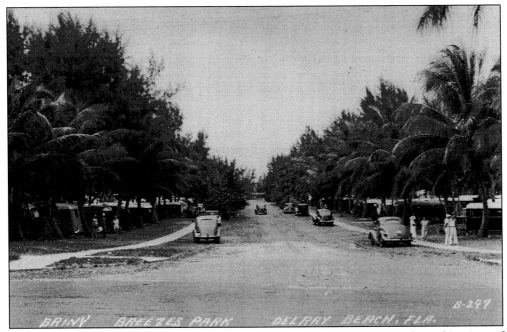

BRINY BREEZES TRAILER PARK. Framed by rows of young coconut palms, this view of Briny Breezes Park, looking west, shows people enjoying the relaxing Florida lifestyle. In the 1930s and 1940s, most of the travel trailers were 18 feet long. A select few were a bit larger at 22 feet long. There was no air-conditioning, and cooking was done outdoors on a kerosene stove. (Courtesy Mann family.)

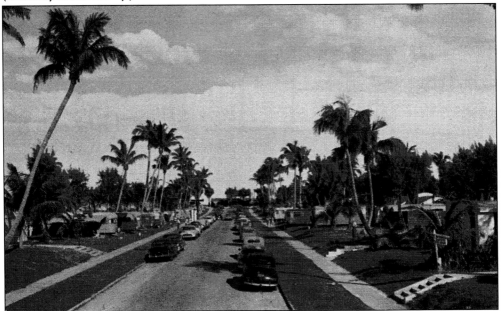

LIFE IS A BREEZE. This picturesque street in the center of Briny Breezes Park is named Ruth-Mary Street. By the late 1940s, the little seaside community of travel trailers, motor homes, and campers was in full swing, especially during the winter months. The sign on the right indicates a laundry facility for residents and guests. (Courtesy Mann family.)

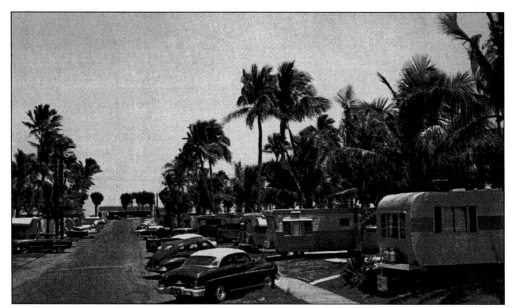

FLORIDA TRAILER PARK. This trailer park is one of many South Florida oases that began to fill with residents as the leaves up North start to change color. The simple living appeals to many people who consider themselves to be seasonal residents. In later years, most Briny Breezes residents own the land their mobile or manufactured home occupies.

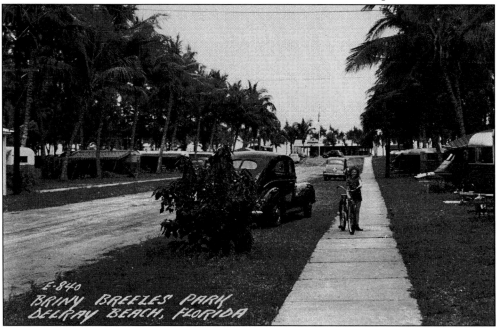

NO PLACE LIKE BRINY. Briny Breezes, a unique trailer park, is known for active but peaceful living. In 1962, the *Boynton Beach News* wrote, "Nowhere would you find a group carrying on so many fruitful activities. Neighbors are friendly without being pushy, privacy is respected and a total esprit de corps exists which assures success to every program undertaken in the community. The ocean itself, along which the park is located, is a constant source of pleasure to many Briny residents." (Courtesy Mann family.)

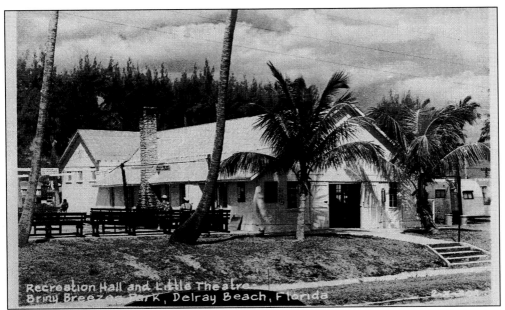

RECREATIONAL HALL. Briny residents enjoyed this community hall with a theater, dancing stage, and shuffleboard courts. The clubhouse burned down in 1956. A new clubhouse along the Atlantic Ocean gained notoriety when scenes from the 2005 Hollywood movie *In Her Shoes* starring Shirley MacLaine, Cameron Diaz, and Toni Collette were filmed there. Residents of Briny Breezes and Abbey Delray South, a retirement community for active seniors, were extras or had small parts in the hit film. (Courtesy Mann family.)

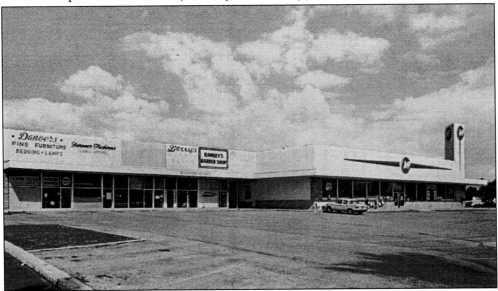

A&P FOOD STORES. The second major shopping center in Boynton was anchored by A&P Food Stores and was located in the 700 block of South Federal Highway. Businesses in the downtown strip mall in 1962 were Danver's Furniture, Dorene's Fashions, Victor's Beauty Salon, Ramsey's Barbershop, the Washerama, and A&P grocery. The car is a Studebaker. This shopping center was still standing in 2006, and the north end of the center is Grace Community Church. (Courtesy Sheila Rousseau Taylor.)

WELCOME TO BOYNTON BEACH. This welcome sign on Federal Highway greets those who enter the town from the north and has been a Boynton Beach landmark for more than half a century. A 1950s brochure welcoming visitors and residents to the city reads, "Business shopping and banking are done easily in a compact but not congested area and an atmosphere of friendly leisure. Good schools, play areas, parks and planned recreation create healthy, happy children. Many different clubs appeal to a variety of interests, and municipal departments protect the citizens. Many residential streets are tree shaded. Retirement homes may be very modest in price."

Seven

LIVING IN PARADISE

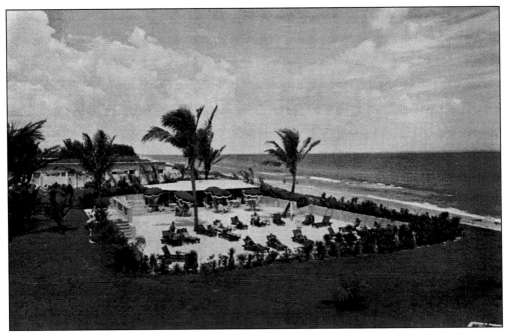

SEA HORSE BATH AND TENNIS CLUB. This image shows the lovely enclave of the Sea Horse Bath and Tennis Club along A1A in Delray Beach. The club, directly on the beachfront, features a swimming pool, tennis courts, luncheon terrace, and a breathtaking view of the turquoise Atlantic Ocean. The retreat was built in 1952 and features 32 patio apartments embodying all the services of a hotel and the advantages of a club.

CRUISING PAST STERLING VILLAGE. This boat cruises north on the Intracoastal Waterway past Sterling Village, a condominium community built in the early 1960s. The village is built on land that Maj. Nathan Smith Boynton bought on his first trip to this area in 1894. The Horace Murray family first lived on the property and grew tomatoes. The land was also used to grow pineapples. An oyster house sat on the northeast section back in the year 1910.

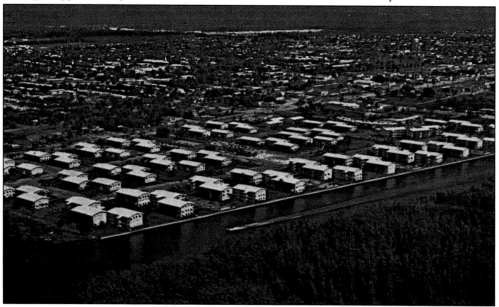

STERLING VILLAGE. In 1965, the first condominiums in Boynton Beach opened just north of Ocean Avenue on a prime stretch of land between Federal Highway and the Intracoastal Waterway. The 840 units housed in 29 buildings originally sold at prices ranging from $8,800 to $9,900. Boynton Beach city commissioner Muir "Mike" Ferguson was one of the original residents of this premier facility, moving into the complex November 1, 1965. Commissioner Ferguson was still living there some 40 years later.

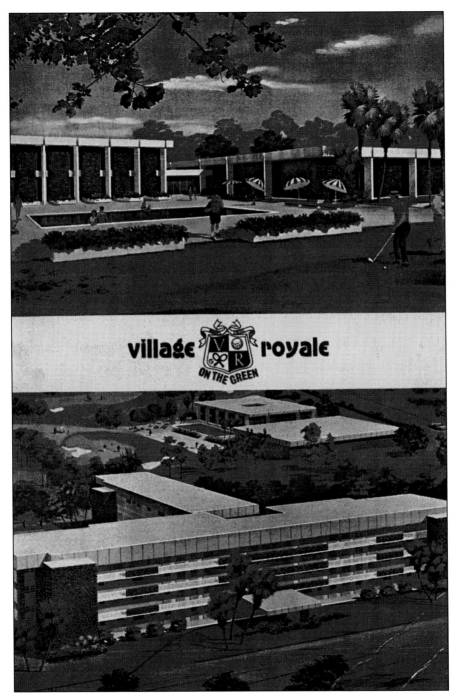

VILLAGE ROYALE. Built by Irving Gross and Emmanuel Marks, the golf-side community of Village Royale on the Green opened in 1971. The luxury condominiums boast two swimming pools, two clubhouses, a large auditorium, a nine-hole golf course, and a host of other perks and amenities. The original price for each of the apartments was $16,999 for a one-bedroom and $19,999 for a two-bedroom; the 88 units sold out quickly, mostly via word of mouth from other excited buyers.

SEA CREST REALTY. The big clock ticking outside ensured this real estate and insurance agency on Federal Highway was a Boynton landmark. Sea Crest Realty was Boynton Beach's oldest and largest real estate firm. In 1962, the agency boasted "12 friendly professional people to serve you." (Courtesy James T. and Bernice Miner family.)

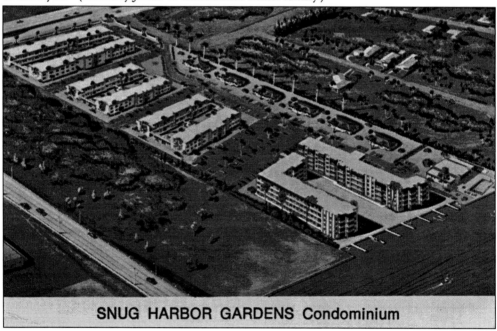

SNUG HARBOR. The condominium community of Snug Harbor on Federal Highway was built in 1973 by developer Alvin Silverman. The last structure was completed by 1975. Some of the smaller apartments sold for as little as $32,000, while two-bedrooms near the water brought several thousand dollars more. Of the 196 units, the most desirable condos are in the four-story buildings along the picturesque Intracoastal Waterway. In addition, the spacious development has 6 two-story apartment buildings and 11 garden villas.

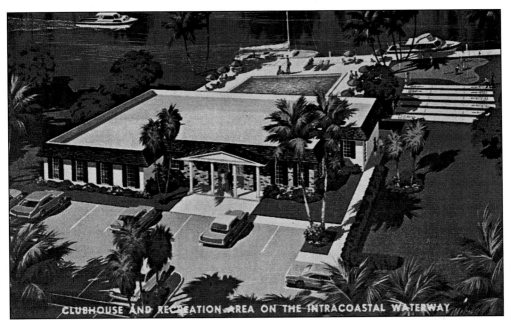

CLUBHOUSE AND RECREATION AREA ON THE INTRACOASTAL WATERWAY

COLONIAL CLUB. Shown here is the clubhouse of the beautiful Colonial Club Condominiums. Built in 1972–1974 on land that used to be a nursery, the complex consists of two sections and has a swimming pool facing the Intracoastal, shuffleboard courts, and a small practice golf course. An exotic tree called Silk Floss (*Chorisia Speciasa*) with orchid-like, pale pink and white flowers that bloom in September was moved from a location on the property during construction of the homes and serves as a reminder of the pioneer roots of the property.

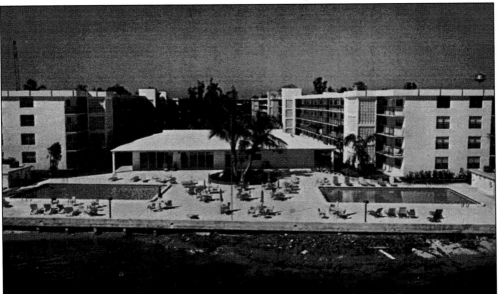

SEAGATE OF GULF STREAM. Shown here is a view showcasing the two luxurious pools at the waterfront condominium apartments called Seagate of Gulf Stream. The *c.* 1973 card notes the campus of the luxury homes along South Federal Highway that encompass 11 acres on a lush tropical atmosphere of a former nursery. Seagate has the charm of a countryside atmosphere in the very heart of the city.

101

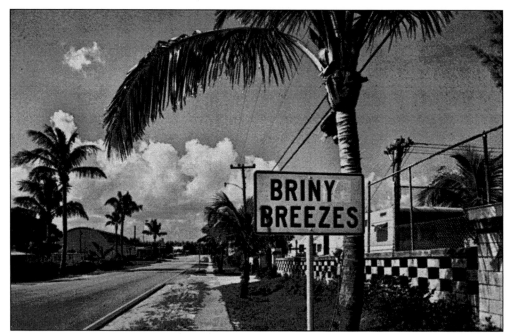

Tween Waters. The township of Briny Breezes is sandwiched between the Atlantic Ocean and the Intracoastal Waterway. Many people aren't even aware of this unique community of trailer homes. The view is looking north on A1A. Gulf Stream Beach, a county recreational beachfront facility, is located to the south of Briny. Gulf Stream Beach has a small underwater reef several yards offshore and is frequented by divers and snorkelers.

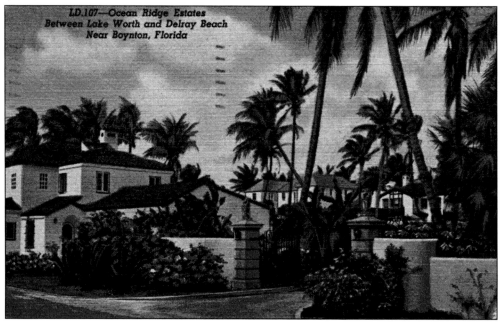

Ocean Ridge Estates. This card mailed in 1954 shows the striking Ocean Ridge Estates. These exclusive rentals surrounded by a gated wall are decked out with elaborate, ornamental landscaping.

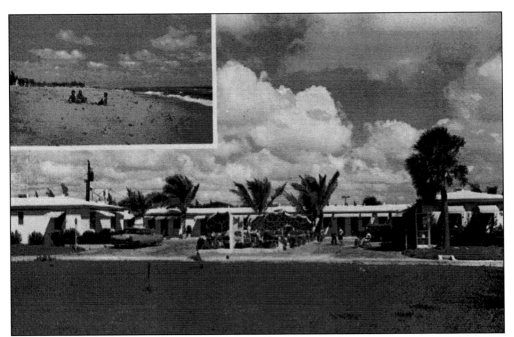

OCEAN RIDGE MOTEL. This motel at 11 Adams Road in Ocean Ridge lies east of A1A. Imagine living a few steps from the Atlantic Ocean and relaxing on a private beach. Ocean Ridge is known for its solitude, seclusion, and small-town living. Many residents living a few miles away don't even know where the town of Ocean Ridge is located.

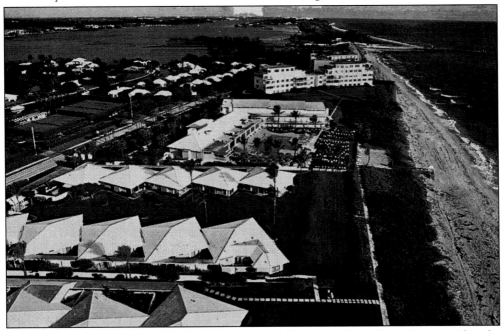

OCEAN CLUB. The Ocean Club of Florida is located directly on the Atlantic Ocean within the McCormick Mile, just south of the Boynton Inlet. The club, founded in 1962, sports a large sparkling pool, luncheon terrace, private lawn and beach, posh dining room, lighted tennis courts, and luxury condominiums.

COFIELD HOMES. During the 1950s and 1960s, thousands of cement-block homes like this were built around Boynton Beach. Retirees found these homes to be affordable, and families were discovering that this area was a nice place to raise children. During this time, many of the new homes were built with carports, jalousie windows, and large screened porches with patio doors. A number of the homes had extra luxuries such as a small, private, backyard swimming pool with a diving board. (Courtesy Boynton Beach City Library.)

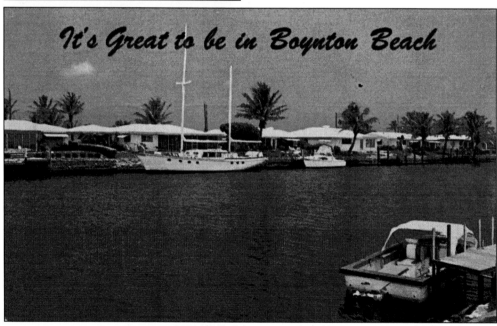

GREAT TO LIVE IN BOYNTON BEACH. The canals and waterways that make up much of east Boynton Beach give residents a rare opportunity to keep a boat in their backyard. Here they can walk to the end of the dock to launch their craft and spend an hour or the day cruising the inland waterways or venturing out into the azure blue Atlantic. Visitors from around the country can sail in to Boynton and stay awhile.

Eight

LAND OF SUNSHINE

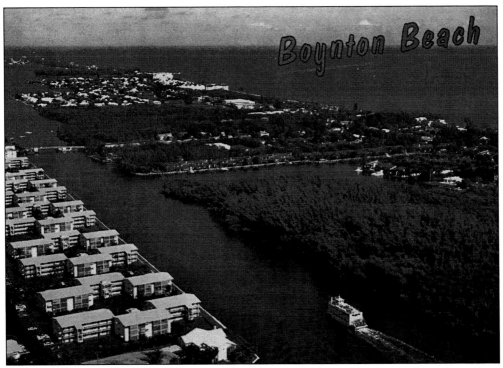

BOYNTON BEACH. The area around Boynton Beach is known for picturesque surroundings and moderate temperatures. No wonder so many scenic postcards like this one continue to be collected and sent to friends and relatives. This aerial view shows a paddlewheel boat heading north on the Intracoastal Waterway. The Ocean Avenue Bridge is seen to the far left. Notice the forest green mangrove swamps on the east side of the Intracoastal.

THIS IS FLORIDA. An early-1960s souvenir postcard touts Florida as "The Sunshine State." Sunbathing, key Florida cities, and points of interest in the state are highlighted. Notice that while the Treasure and Gold Coasts look heavily populated, Boynton Beach is not identified. Boynton was still a sleepy little coastal town, and few postcard designs were printed with the moniker Boynton Beach on the front.

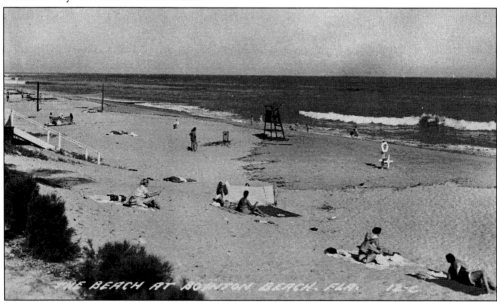

THE BEACH. Our wide, white, sandy beaches have been a place of rest, relaxation, recreation, and solitude for generations. This *c.* 1950s image reflects a typical day at the beach with swimmers, sunbathers, and volleyball net. Notice the vintage rescue equipment. The first lifeguard in Boynton Beach was a volunteer named George Zolphy, who built a stand and watched over the bathers. Later the city hired him as the first lifeguard. (Courtesy Sheila Rousseau Taylor.)

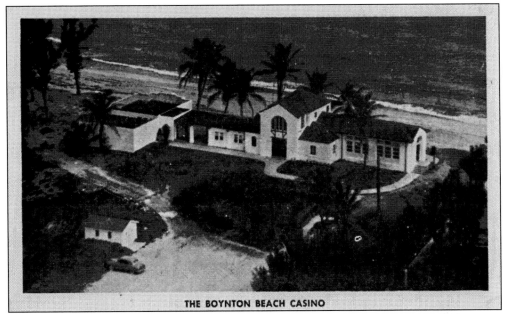

THE BOYNTON BEACH CASINO

CASINO AND BATH. Here are two different views of the much-loved Boynton Beach Casino and Bathhouses on the Atlantic Ocean. This popular community waterfront recreational facility was built in 1928 and served generations of happy families until it was torn down in 1967. The top view is an aerial shot of the west side. This postcard with the white border is *c.* 1930. The lower image is from the 1940s and shows the parking lot with only a few cars and visitors. The casino holds happy memories of teen parties, church spring luncheons, impromptu picnics, class outings, and family reunions, to name just a few. The casino had a large dining room, concession stand, and bathhouses with showers and dressing rooms. Upstairs was an apartment for the custodian. The beachfront property was renovated and in 1984 opened as the present-day Oceanfront Park.

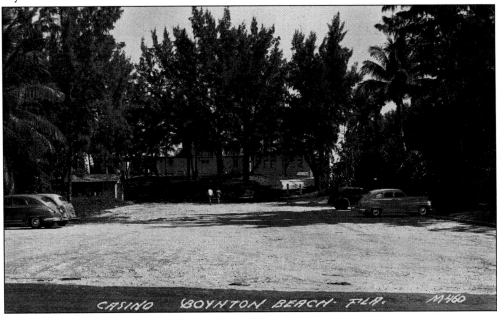

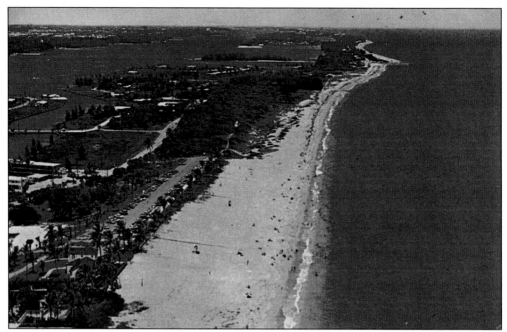

VIEW FROM ABOVE. This *c.* 1960 view from above shows the Boynton municipal beach located along the Atlantic Ocean in Ocean Ridge. The Boynton Inlet to the north can be seen at the top of the image. Most of the undeveloped land shown has been transformed into mansions or luxury condominiums.

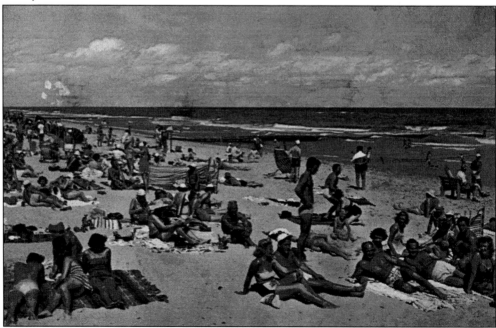

BEACH SCENE. Families and couples soak up the rays in this crowded 1950s beach scene. The card, mailed from Boynton Beach on November 15, 1954, and addressed to Mina Mason, Cattaraugus, New York, bears a chamber of commerce–type advertisement: "Never-ending summertime, with mild blue skies, soft sand and warm surf on the glorious beaches of the Southland."

LOOKING WEST. In 1969, a visitor mailed this card from Boynton Beach to her grown children in South Plainfield, New Jersey. The view shows the town of Briny Breezes and the south end of the city of Boynton Beach taken from the ocean. Notice the Boynton water tower on the right of the postcard. The new water tower was built in 1992 at the same location of Woolbright Road and Seacrest Boulevard.

Boynton Beach, Florida

PICTURESQUE SURROUNDINGS. A drive down scenic A1A is one of the most pleasurable, affordable outings for residents and visitors of all ages. A three-quarter-mile-long stretch south of the Boynton Inlet runs through Ocean Ridge, Gulf Stream, and Briny Breezes to Delray Beach. The drive to the north includes Manalapan, Hypoluxo, Lantana, South Palm Beach, Lake Worth, and Palm Beach. Palms and mansions and the emerald-green Atlantic Ocean are seen along the way.

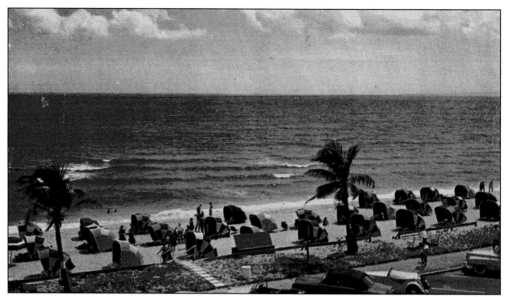

DELRAY BEACH. This postcard, featuring Delray's fashionable beach adorned with colorful cabanas and swaying palm trees, was mailed February 20, 1962. Delray had a writers' and artists' colony and was a seasonal home for notables such as Edna St. Vincent Millay and cartoonist Herb Roth. The city of Delray Beach was originally named Linton after William A. Linton, who came to the area in 1894 and bought 160 acres of land. In 1901, the name was changed to Delray.

HYPOLUXO. This postcard of Hypoluxo, dated 1959, shows the town's tranquil beach. The name Hypoluxo comes from the Seminole name for Lake Worth and roughly translates to "Water all around, no get out." Hypoluxo is at the south end of Lake Worth, which was originally was a saltwater lake. The first inlet for what would become the Intracoastal Waterway was cut in 1877. The first residents of Hypoluxo Island included the Hannibal Dillingham Pierce and the Andrew Garnett families.

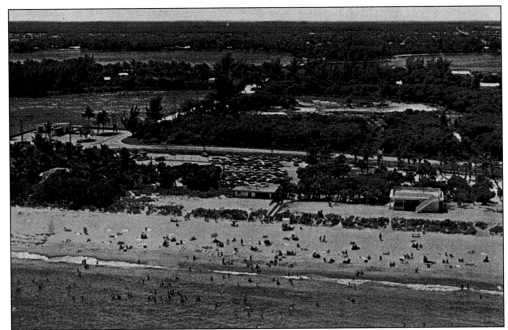

LANTANA. This *c.* 1969 aerial view of the lovely Lantana Beach north of Boynton shows the mostly undeveloped land between the beach and the Intracoastal. The town was named Lantana Point after the wild Lantana plant by Morris Benson Lyman, one of the earliest residents, who arrived in 1888. Lyman was the first postmaster and opened a general store and Indian Trading Post. The town of Lantana was incorporated in 1921, when there were a mere 100 residents.

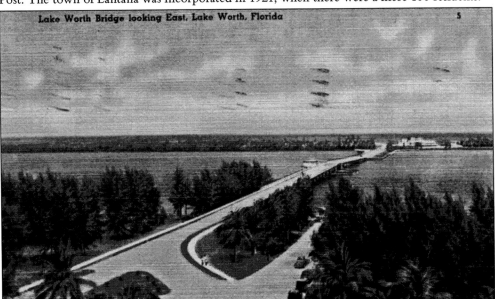

LAKE WORTH. This vintage postcard view shows the Lake Worth causeway looking east to the ocean beach. The first wooden automobile bridge over Lake Worth, completed in 1919, was destroyed in the 1928 hurricane. The city of Lake Worth was incorporated in 1912 and bills itself as "Where the Tropics Begin." One of Lake Worth's most famous residents is television star Deidre Hall.

SURF'S UP. Surfers socialize on the beach before paddling out to the breaking waves. Surfing has become a popular activity with school-age children, teens, and athletic adults. Researchers say people were surfing in Hawaii by 400 AD. The first boards were crafted from wood. In 1908, the sport reached California and spread across the United States to Florida. The Beach Boys musical group brought recognition to the sport, and we've been riding the wave ever since.

CATCHING A WAVE. On a clear day, with endless miles of deep blue behind them, surfers ride a wave to shore. The art and athleticism of surfing and the adventure of finding the perfect wave beckon surfers to the sea time and time again. Nomad Surf and Sport, one of Florida's original surf shops, opened in 1968 in Boynton Beach and makes custom surfboards. Boynton Beach has 1,000 feet of public beach. Other popular surfing spots are the Boynton Inlet and Gulf Stream Park.

SURFING. A teenaged Bonita Beach (Bonnie for short), transplanted from California, introduced surfing to the Boynton-Delray area. By the early 1960s, it was surfing mania in South Florida. If you couldn't afford a surfboard, you rented one or installed an empty surf-rack on the roof of your car for cruising down U.S. 1 or Highway A1A. A good time for surfing in Boynton is late fall, winter, or early spring when nippy, northeasterly winds are felt, and the beach is deserted. Those cold, steady winds push tons of water to shore, creating large swells at steady intervals.

TROPICAL POSTCARD CLUB. The Tropical Postcard Club has been in existence for 27 years. They used to have their annual postcard show, the Tropobex, at the Boynton Beach Civic Center. The club met monthly in the Royal Palm Clubhouse at 544 NE Twenty-second Avenue until 1987, when the clubhouse was torn down. They now meet at the Pompano Beach Civic Center. A member, commemorating their annual postcard show, created this specially designed postcard. Members collect and trade postcards and educate newcomers in the hobby of deltiology.

TOURIST HUMOR. Gag postcards featuring cartoon tourists and fanciful scenes like these were a favorite to send the folks back home. It was customary for visitors to brag about the warm sunny weather by sending these postcards to those who were shoveling snow in Northern locales. Funny postcards were sold in stores like Belvedere Five and Dime in the Kwik Chek Plaza and in any of the numerous quirky roadside souvenir and shell shops along Dixie Highway.

Nine

CATCH OF THE DAY

THE ATLANTIC OCEAN AT FISH HAVEN BOYNTON, FLA. 3734

"FISH HAVEN." With its inlet from the Intracoastal Waterway to the best fishing in the county in the Atlantic waters, it's no wonder the Boynton Inlet was called Fish Haven. Professional anglers, sports fishermen, children, and families flocked to Fish Haven every day of the week. Residents and visitors still find the Boynton area a great place to farm, fish, vacation, and live. (Courtesy Boynton Beach City Library.)

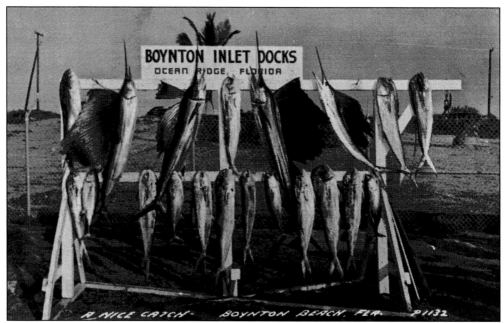

A NICE CATCH. This picture postcard was taken at the Boynton Inlet Docks, located in Ocean Ridge. Over the years, countless photographs of fishermen and their bountiful catch have been taken at Boynton Inlet Docks. The rack is loaded with a variety of ocean fish, including some large sailfish. The sailfish is the official fish of Boynton Beach and is used today in the city seal. The postcard was mailed February 14, 1952. Postage for the card was 2¢. The message echoes the feelings of many anglers of the day.

OLD SALTS. Harold Lyman is the man on the left. Often sea-faring captains are referred to as "old salts." Some are born with sailing in their blood. The tangy taste of brine is evidence for swimmers, surfers, and sailors that the Atlantic waters contain salt. Rivers and streams channel rainwater to the ocean and the salt from rocks and soil is dissolved in the mixture and floats to the sea. Storms also disturb the sea floor sediments, releasing more minerals. So day by day, the sea gets saltier. (Courtesy Cindy Lyman Jamison.)

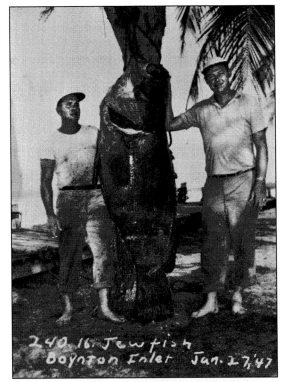

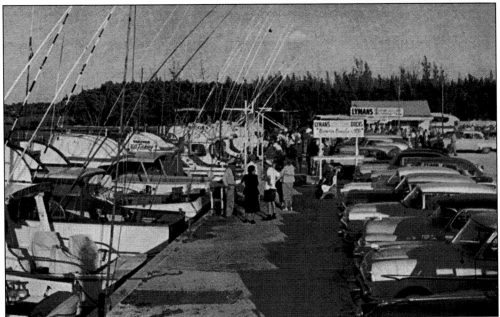

LYMAN'S DOCK. The active marina and sport fishing dock owned by Capt. Kenny Lyman was a popular destination for out-of-towners and weekend sports fishermen. Captain Lyman took great pleasure in winning local fishing contests and helping young children learn to hook "the big one." Countless trips into the calm blue waters and the bounty brought back from the sea were captured with souvenir photographs taken by Kenny's wife, Penny, or a dockworker.

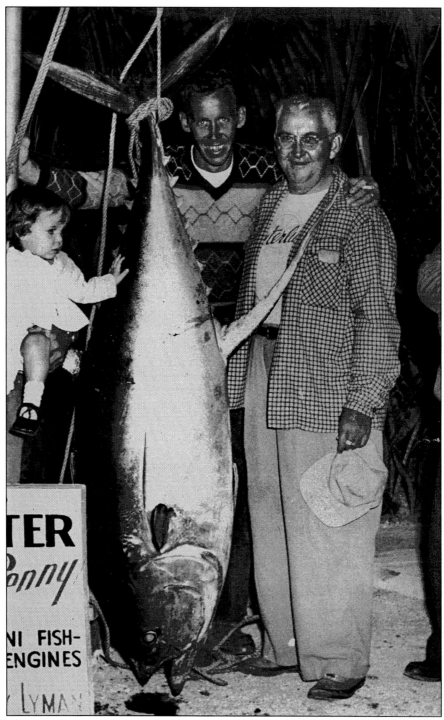

TUNA TIME. This was taken at the Boynton Inlet Docks in 1952. The tuna was caught on the *Lucky Penny.* Capt. Kenny Lyman is cut out of the picture, but he is holding his toddler daughter, Cindy, up to touch the fish. Also pictured are mate "Hoppy" Hotchkiss (left) and angler Les Curfman (to the right). (Courtesy Cindy Lyman Jamison.)

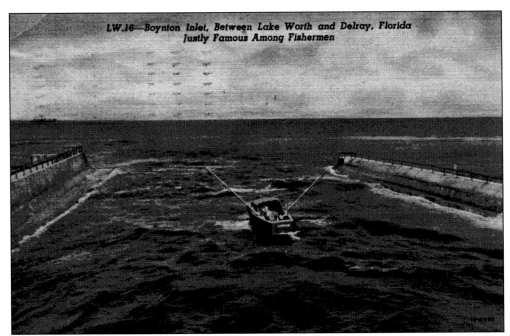

BOYNTON'S FAMOUS INLET. This linen postcard portrays a small fishing boat with out-riggers heading out to sea just as the sun is coming up across the Atlantic. A distant ship is seen on the horizon. The Boynton Inlet, located between Lake Worth and Delray Beach, is justly famous among fishermen.

BOYNTON INLET. Fishermen and spectators relax at the Boynton Inlet. This bridge was constructed in 1952 and links the coastal towns of Ocean Ridge and Manalapan. The pleasure boat is headed out from the Intracoastal Waterway into the Atlantic Ocean. Boynton is known as the "Gateway to the Gulf Stream" and is known as a place for superb fishing.

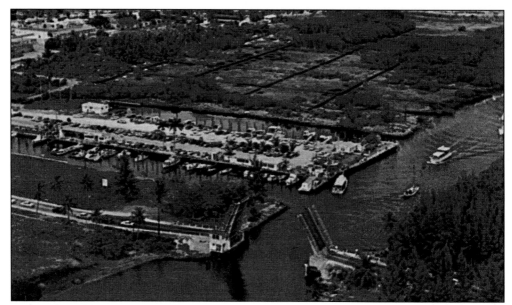

OCEAN AVENUE BRIDGE. This aerial view of the Ocean Avenue Bridge *c.* 1960 shows the Intracoastal Waterway and the Boynton Fishing Fleet. Notice the drainage ditches running across the low-lying green area. They were put in during the 1920s or 1930s for mosquito control. Businesses found at these marinas were Wendell Hall's Charter Boat, Florida's Finest Fishing Inc., Robert Klinger Charter Boat, Two Georges Marina, George Culver Charter Boat, Lyman's Sport Fishing Dock, Harry Lawson Drift Boat, and Homelite Marine Engines.

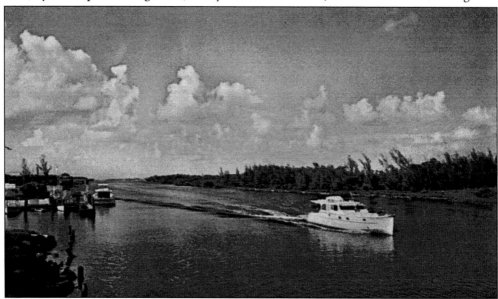

SAILFISH CITY. A pleasure craft makes its way along the Intracoastal Waterway in Boynton Beach, "The Sailfish City." In the winter months, many manatees swim and frolic in the warm waters of the Intracoastal. Boaters are urged to stay in the channel and reduce their speed so boat propellers don't hurt the slow, massive sea cows. Rare are the days in Boynton Beach when it is too cold to go swimming. Generally the water is calm with small waves breaking on the shoreline, and the summer sea is often as still and warm as bathwater.

120

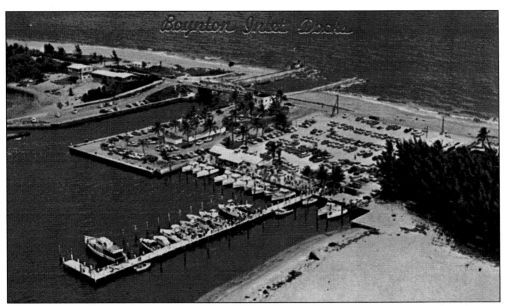

CHARTER BOATS. The top postcard shows charter boats at the Boynton Inlet Docks forming a neat pattern from the air. The sandy cove on the right is now Ocean Inlet Park, run by Palm Beach County Parks Department. The lower photograph is another aerial view of our famous Boynton landmark where droves of fishing boats can be seen sailing in and out of the inlet most days at 8 a.m., noon, and 5 p.m. On rare occasions, the weather is too rough for boating. Tropical disturbances form off the coast of Africa each year from June to November, bringing tropical storms and the occasional hurricane into our path. These days, residents have ample warning and are more prepared for the powerful winds and storm surge. Palm Beach County was badly damaged in the 1928 hurricane as was the area near Lake Okeechobee; many people lost their lives. Most recently, Hurricanes Frances and Jean in 2005 and Hurricane Wilma in 2006 inflicted severe damage on the Gold Coast.

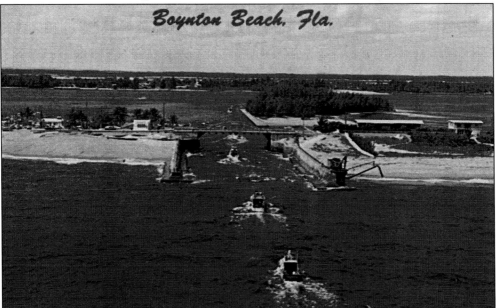

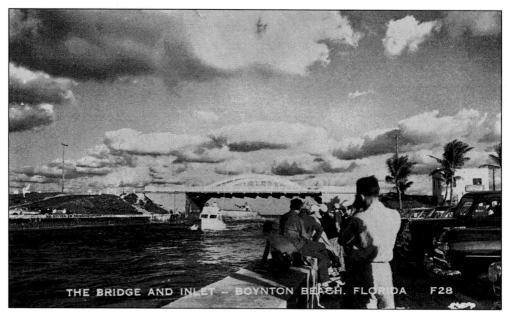

THE BRIDGE AND INLET – BOYNTON BEACH. FLORIDA F28

INLET ANTICS. The Boynton Inlet was a place to see and be seen. People, as well as hungry pelicans, eagerly watch for the fishing fleets arriving back from deep-sea fishing excursions. The thrill of catching a "big one" can be told over and over to friends in the North. (Courtesy Boynton Beach Historical Society.)

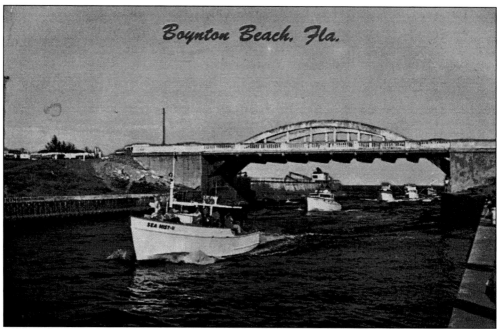

Boynton Beach. Fla.

INLET BRIDGE. The arched bridge spans the Boynton Inlet on A1A between Ocean Ridge and Manalapan. The swift currents and narrow width made the channel hard to navigate. The pictured bridge was dismantled in April 1974 to make way for a new bridge over the inlet. A1A crosses three inlets in Palm Beach County: Boca Raton, Boynton, and Jupiter, but it bypasses the Palm Beach Inlet.

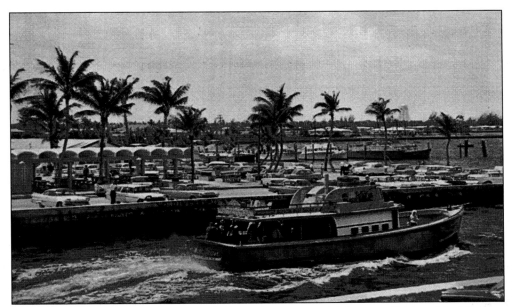

MART-JEAN. This early-1960s postcard shows the commercial deep-sea fishing ship *Mart-Jean* heading back to the Boynton Inlet Docks. As the boat passed through the inlet, passengers, eager to show off their catch, wave to friends or relatives waiting at the Boynton Inlet Docks. The sea captains didn't have far to go into the blue Gulf Stream waters before catching a large variety of game fish. The old Boynton water tower can be seen in the distance on the right of the image.

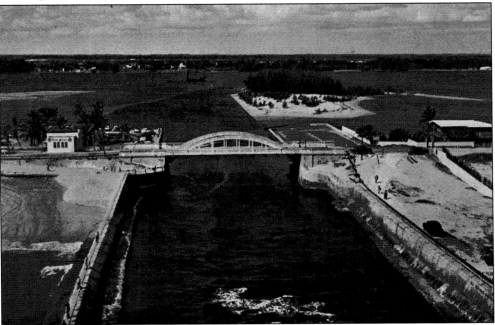

INLAND WATERWAY. The Florida Coast Line Canal is now referred to as the Inland Waterway or the Intracoastal Waterway. The name "canal" was said to be offensive to newcomers to the area, and they preferred the term "waterway." Before the inlets were dug, the Intracoastal Waterway was a freshwater canal, originally known as Lake Worth.

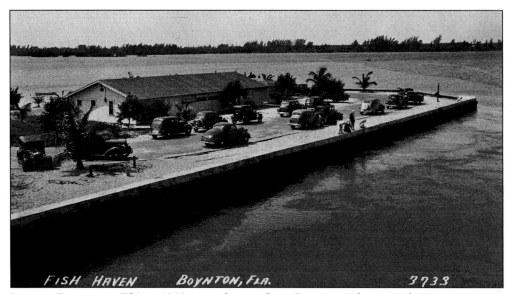

FISH HAVEN BOYNTON, FLA. 3733

LIFE IN BOYNTON. This *c.* 1940 view shows a busy Boynton Inlet, or Fish Haven as it was known. By 1950, Boynton had about 2,500 permanent residents and many seasonal visitors. (Courtesy Boynton Beach Historical Society.)

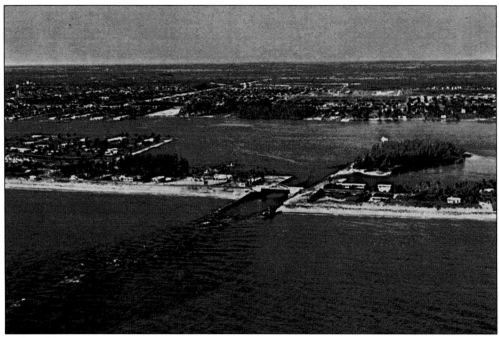

SAND TRANSFER STATION. The inlet's original sand transfer plant was built in 1936 and rebuilt in the 1960s. The transfer plant constantly moves sand, about 3,600 tons a year, from the north to the south side. An outlet pipe transfers the sand to the beach on the south side of the inlet.

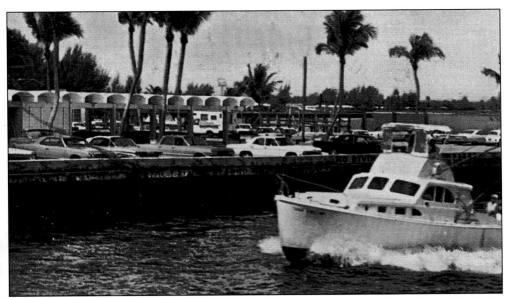

BOATING AND BEACHCOMBING. This boat makes its way past a bevy of automobiles parked at the inlet. The inlet and the beach are popular places for gatherings and leisure activities. The sparkling Atlantic Ocean beckons to sunbathers, sailors, and deep-sea fishermen. Back in the 1940s, children used wooden, glass-bottomed buckets to magnify underwater shells, tropical fish, and other sea creatures. The pail could be used to carry the treasures from the sea home for further observation.

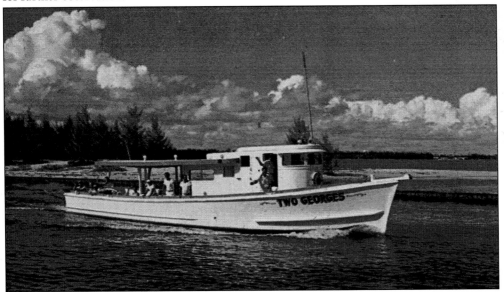

TWO GEORGES MARINA. A fishing boat from the Two Georges fleet passes Beer Can Island on its way out the Boynton Inlet. The inlet is a favorite spot for weekend anglers and picnickers who say the small-town atmosphere makes the area seem like a city within a city. Scuba divers and snorkelers find colorful sea life and an array of visual treasures in the reefs just off the shore. People are irresistibly drawn to the sandy beach to watch the rocking waves and hear the soothing rhythm of the breakers. In recent years, developmental changes have added more glitter to the community.

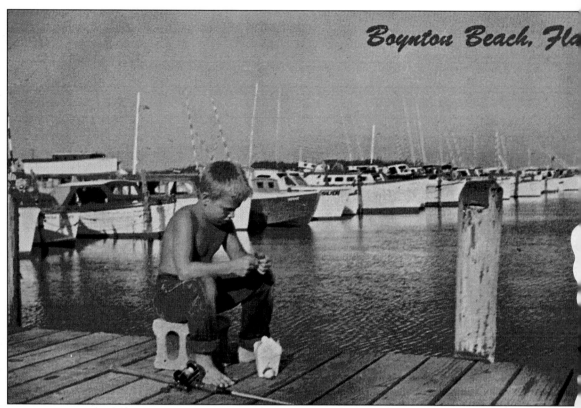

LOOKING TO THE FUTURE. This youngster sits on the dock with his fishing pole and tackle wearing rolled-up jeans and a contemplative look. Behind him the sun is shining, the water is calm and sparkling, and the boats are lined up in a row. Perhaps he is reflecting on the past, or maybe he's thinking about the future. This image epitomizes the friendly, easy-going seaside city of Boynton Beach. (Courtesy Cindy Lyman Jamison.)

126